MODERN CALLIGRAPHY

& hand lettering

LAUREN COOPER

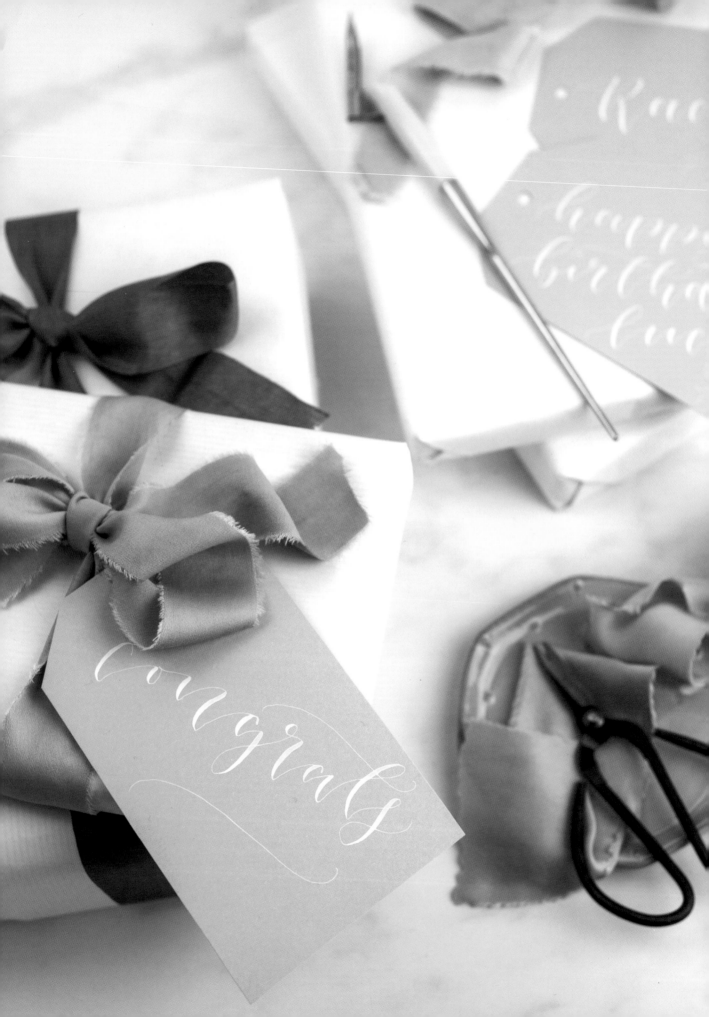

INTRODUCTION

From the author . 8
A brief history of calligraphy 10
Introduction to modern calligraphy 12

TOOLS

Essential items . 16
Extra tools & equipment 20

GET WRITING

Getting started . 24
Drills . 26
The alphabet . 28
Common mistakes . 30
Joining letters . 32
Proportions . 34

INTRODUCING SOME STYLE

Practice & inspiration 38
Composition & layout 40
Handmade work . 42
Digitising your calligraphy 44
Printing processes . 46
Putting yourself out there 48

INKS & COLOUR

Choosing ink . 52
Mixing your own inks . 54

PROJECTS

Paper . 58
— *Watercolour Greetings Cards* *60*
— *Envelope Addressing* *64*
— *Wall Art* . *68*
— *Celebration Banners* *70*
— *Gift Tags* . *74*
— *Sparkly Star Cupcake Toppers* *76*
— *Menu Planner* . *78*
— *Neon Notecards* . *80*

Other materials . 82
— *Wooden Bar Menu* . *84*
— *Tabletop Chalkboard Menus* *88*
— *Slate Drinks Dispenser Sign* *90*
— *Slate Cheeseboard* *92*
— *Mirror Lettering* . *94*
— *Food Container Labels* *98*
— *Small Items with Smooth Surfaces* *100*
— *Shells* . *104*
— *Small Objects with Textured Surfaces* *106*

Weddings & events . 110
— *Wedding Invitations* *112*
— *Monogram Wax Seals* *118*
— *Personalised Menus* *122*
— *Tag Place Settings* *124*
— *Confetti Bag Stickers* *126*
— *Glass Frame Table Numbers* *128*
— *String Table Plan* . *130*
— *Plant Pot Favours* . *134*
— *Bespoke Stamp Thank-you Cards* *136*

Celebrations . 138
— *Valentine Confetti Envelopes* *140*
— *Snowy Menu & Place Cards* *142*
— *Festive Baubles* . *146*
— *Wrapping Paper* . *150*
— *Mother's Day Frame Decorations* *152*
— *Father's Day Leather Keyring* *154*

Stockists & suppliers 156

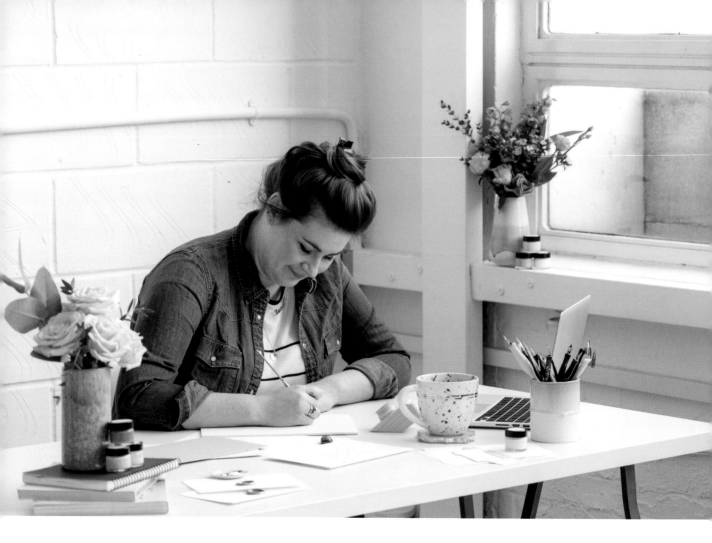

Hi there! I am Lauren and before we go any further I want to thank you from the bottom of my heart for picking up my book. As I am writing this page, which I left until last, I still can't quite believe that this book is really happening. Ever since I was a little girl I have loved books, and reading, and to think that there will be one with my name on one blows my mind, even though I have spent the last twelve months planning and writing it.

My calligraphy journey started in 2013 when I was struggling to figure out the career path I was meant to be on. After studying fashion journalism at university, then graphic design at an adult education college, I had just quit my supervisor job at a designer fashion boutique with some very poorly thought-through plans of starting up a wedding stationery business. I spent a year feeling totally lost and overwhelmed. Calligraphy was my saving grace through this time. I am not particularly artistic, but I am creative, and I have always loved writing. In a digital age, I have always been the girl who carries around a paper diary, and countless notebooks filled with lists and musings. So, when I started seeing forms of calligraphy on Pinterest and Instagram, I wanted to try it out.

I went to an art shop, bought completely the wrong tools and gave it a go! I was using the wrong nibs, the wrong paper, and had no idea about anything to do with calligraphy. My work looked a mess but I immediately fell in love with the process. I spent months getting lost in stacks of paper, ordering a ton of nibs online and spending every moment I could practising. At the time, calligraphy wasn't as popular in the UK as it was in the US, which meant I struggled to find the correct tools, but then the wonderful Molly Suber Thorpe published a book called *Modern Calligraphy* and my eyes were opened to the correct way to do things, like preparing a nib properly. For months I hadn't been doing that and kept wondering why ink never flowed correctly. I found specialist online retailers in the UK where I could order the nibs

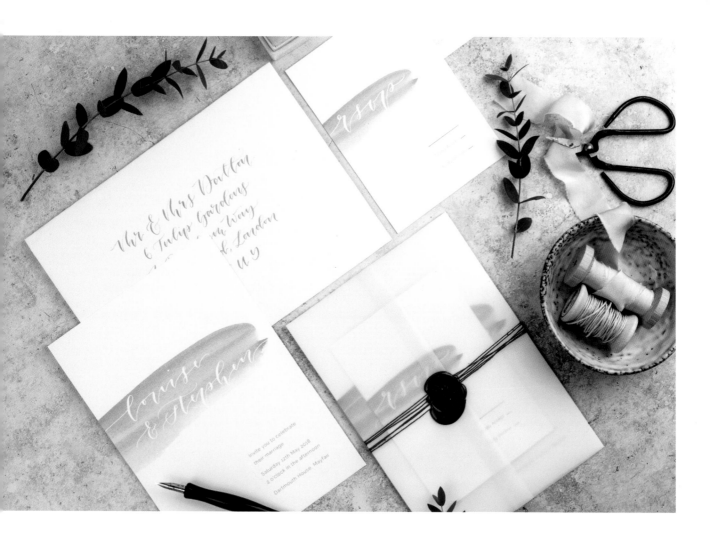

that I would end up falling in love with, and started to see a real improvement in my lettering, although calligraphy remained a hobby, and something I did for friends, until I had my son in April 2015.

Having a baby gave me the drive that I needed to really think about what I wanted to do and figure out how to turn something I adored doing into a business. I desperately didn't want to go back to working full time, with a long commute, but as much as I fell into my new role of being a mother, I also knew it couldn't be my only role. I needed an occupation – not only for my sanity but also to show my son that it's important to have aspirations. He was, and still is, my inspiration and the drive for my company. It was from here I started to put together my big plan for launching a calligraphy business, and in January 2016, when Oscar was eight months old, I launched Oh Wonder to the world (aka my Facebook friends and a handful of Instagram followers!) with a basic website and some shoddy pictures I had agonised over.

I fell into a wonderful community of wedding professionals, worked every spare second I had, and from there the company grew.

I now call myself a professional calligrapher, have a website filled with amazing professional photographs, have worked on countless weddings, taught hundreds of people the art of modern calligraphy, worked with some huge and brilliant brands, and now I have written a book. It has been, and continues to be, a journey of self-discovery that I am incredibly grateful to be on. I am surrounded by love and support from family and friends, old and new, and I still have to pinch myself that this is real and what I do is actually a job. So, I hope you enjoy this book and learn something from it, and most of all I hope that calligraphy offers to you what it did for me – a creative outlet that pushed me to be so much more than I ever thought possible.

Lauren x

A BRIEF HISTORY OF CALLIGRAPHY

Calligraphy is the visual art of writing. It is a centuries-old art that can be found in many, many different forms all over the world, each with a rich and fascinating history. The dictionary definition of calligraphy is 'decorative handwriting or handwritten lettering'. The word calligraphy itself was coined in the early 17th century, and combined the ancient Greek words *kallos* meaning 'beauty' and *graphein* meaning 'write'. The word literally means beautiful writing. Knowing that, how could you not be drawn into the simple, classy elegance that is modern calligraphy?

While there are lots of different forms of calligraphy, the one that we are particularly interested in, as it was where the form of modern calligraphy that I practise came from, is copperplate or, as it used to be known, English Roundhand.

In mid-17th-century Britain, the need for young men who were educated in penmanship and record-keeping had grown due to the increase in trade opportunities. Before the invention of typewriters, this was a prolific career, filled with opportunities. Roundhand was favoured as the script for business because of its legibility and the speed at which a trained penman could write it. Schools were established where young men could go to learn penmanship and accounting, at which the teachers became known as master craftsmen.

These writing masters started to produce copybooks of their work to give to the students so that they could copy the handwriting. The books were produced by means of Copperplate engraving, during which the engraver transferring the penman's work could make adjustments and tidy up any imperfections before printing. This led to to almost unimaginably perfect handwriting being printed, which is where the name Copperplate calligraphy came from.

During the 19th century, mainstream education was established in Britain and handwriting was taught to all schoolchildren, which duly led to a decline in the status of a writing master. Then, when the inflexible ballpoint pen was invented in the 20th century, the style-defining thick and thin strokes of calligraphy were relegated to an art form.

Of course, calligraphy has still been practised over the years, but it has not been seen as a necessity. In recent times, however, it has become popular again in the form of modern calligraphy. It features at the top of wedding trends lists, and is seen adorning some of the biggest brands' PR and marketing materials. Pinterest is filled with images of it, and modern calligraphy workshops are being taught everywhere. Calligraphy has seen quite the revival – something that I am fully on board with!

Census 1851.

		Males	Females
Population	157.696 —	69.115 —	88.581.
— " —	166.956	76.144 —	90.812
— " —	95.329.	42.276 —	52.567.
— " —	58.429.	25.083.	33.346.
— " —	55.932. —	27.149.	28.783
— " —	24.640. —	11.918. —	12.722.
— " —	73.230. —	31.920. —	41.310.
— " —	36.406. —	17.377. —	19.029
— " —	65.609. —	32.494. —	33.115. —
— " —	46.345. —		
— " —	139.325. —	63.673. —	75.672
— " —	64.778. —	31489.	33289
— " —	54.667. —	23574 —	31.093
— " —	90.193. —	44.081.	46.112
— " —	48.376. —	23496. —	24.880.
— " —	56.538 —	25.475.	31.063
— " —	54.214 —	25.832.	28382
— " —	44.460 —	21.570. —	22890

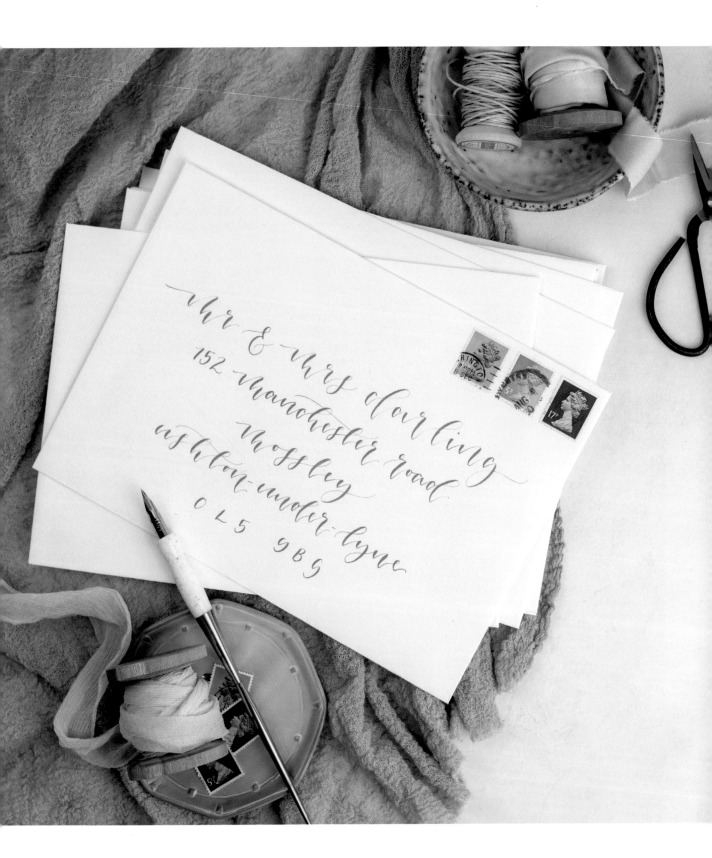

A modern calligraphy envelope design

Modern calligraphy is a style of pointed pen calligraphy that has derived from the tradition of Copperplate calligraphy. While Copperplate is regular, structured and full of perfect curves and flourishes, modern calligraphy is a lot more flexible and offers the potential for your style to be whatever you want it to be. That is the beauty of it – you can take all the basics and then put your own spin on them, creating a unique style that is perfectly you. If you search for 'modern calligraphy' on the internet, you will see hundreds of thousands of images that, while all examples of modern calligraphy, are each wonderfully different and individual. Modern calligraphy allows you to inject your own personality and taste into it and, while the journey from first picking up a pen to being happy with your style might be a long one, it is full of experimentation and fun.

In a digital age in which we text instead of call, and email instead of write, modern calligraphy can be a welcome break from the continuous electrical buzzing around us. It is a quiet and relaxing way to spend your time, especially at the beginning when it is all about repetition and building up your strokes. Take a moment, play some of your favourite music and immerse yourself in the quiet comfort of ink on paper. I really believe that anyone can do modern calligraphy, but there isn't a magic pen that you can pick up that suddenly makes your handwriting better. It involves hard work, and lots and lots of repetition, along with plenty of frustrating moments and wasted paper, when you'll most probably want to give up and go back to using a ballpoint pen to scribble out shop-bought birthday cards. However, with time and effort, I honestly have faith that you will get there and will eventually be presenting handmade cards to everyone for every occasion.

Don't worry if you have messy or scribbly handwriting – it has little or no bearing on the way in which your calligraphy will end up looking. My normal list-making handwriting looks totally unlike my calligraphy; I hold the pen differently and my letterforms for the most part are completely different, so don't panic.

You will find me talking about repetition a lot throughout the first section of this book. When you first learned to write at primary school you didn't pick up a pen and start writing full words straight away. You were taught exercises and shapes, then letters and then words, and this is how we will approach learning modern calligraphy. The key to improving is performing basic exercises and letterforms over and over again. It is through this repetition that we start to build up our muscle memory, and that calligraphy becomes second nature. Eventually your brain no longer has to think about the way in which your hand is moving to form the letters, it just has to think about the words you are writing, because that muscle memory is in place. We don't want or need to replace our normal handwriting – no one has time to get their pen and ink out to write the weekly shopping list (although this certainly would be an excellent way to practise) – we just want to add a 'fantastic calligraphy' subcategory in our brains.

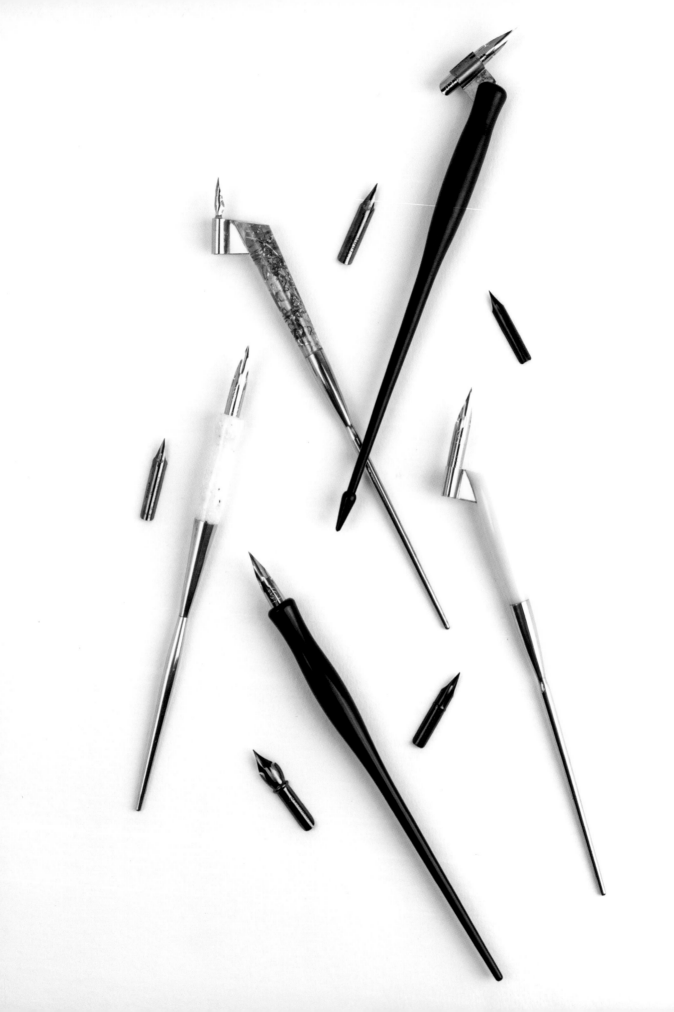

tools

CHAPTER ONE

Before you can start to learn how to make beautiful letters and words
you need to source the tools that are used to make them.

So here's the fun part: let's get shopping.

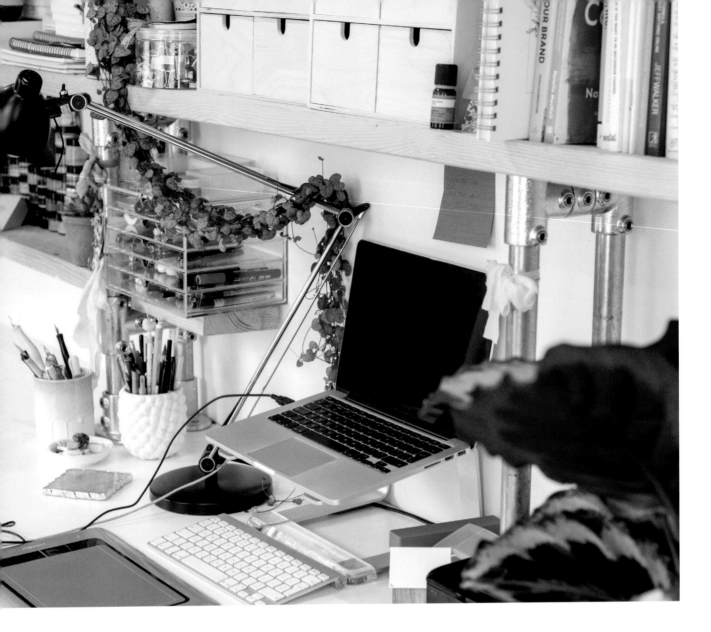

You don't need a huge amount of tools to start calligraphy, although, trust me, you can definitely fill a studio once you get going. The beauty of the art is that the basic kit you require is relatively inexpensive, small and transportable, making it easy to grab when you have a spare moment for that all-important practice.

There are plenty of items that you could add to your basic kit list, some of which we will be looking at further on in this book, and you could really go to town with different-coloured inks, assortments of nibs and fancy pen holders, but to begin with these items are all you need to get started.

BASIC CALLIGRAPHY KIT

– *Pen holder*

– *Pointed nib*

– *Ink*

– *Practice pad*

– *Pencil & eraser*

– *Kitchen paper*

– *Small cup of water*

STRAIGHT HOLDER

OBLIQUE HOLDER

PEN HOLDERS

There are basically two types of pen holders that are used in modern calligraphy: the straight holder and the oblique. The straight holder is as you would imagine: a straight pen where the nib goes into the end. The oblique holder holds the nib at an angle, helping you to write at a slant. In Copperplate calligraphy, the accepted slope of the letters is 54 degrees and the oblique holder positions the nib at this angle. I personally always use a straight holder; my standard style tends to be quite upright so I find the oblique holder angle doesn't feel natural. For beginners, I always suggest starting with a straight holder and then, as you become more comfortable with what you are doing, try an oblique holder, especially if you find you naturally write at an angle.

Pen holders come in various materials, and it is worth buying a few to figure out which you are most comfortable using. Most are relatively inexpensive, although you can go all out and find handmade and carved holders that are really special. For starting out, I recommend a Speedball Straight Pen Holder. These holders are very basic and cheap but they are absolutely brilliant workhorses, ergonomically designed to help you with the positioning of your hand. Although I own a lot of (potentially too many, if that is even a thing) different holders, it is my basic speedballs that I come back to again and again. You will find a list of my recommended suppliers at the back of the book.

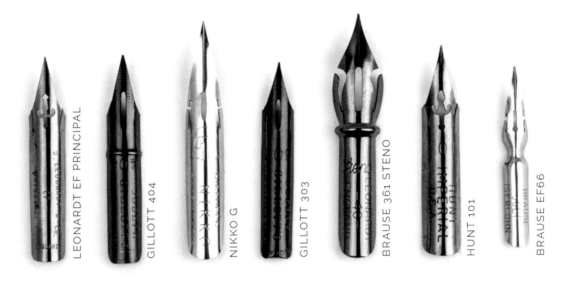

LEONARDT EF PRINCIPAL · GILLOTT 404 · NIKKO G · GILLOTT 303 · BRAUSE 361 STENO · HUNT IMPERIAL · HUNT 101 · BRAUSE EF66

NIBS

There are many different nibs that you can use for modern calligraphy, but for clear differentiation between thick and thin strokes, choose a pointed nib, rather than the squared ones you might see in some calligraphy kits (these are used for gothic forms of calligraphy).

Pointed nibs work by opening up and releasing lots of ink when you apply pressure, creating a lovely thick stroke, and when you reduce the pressure, the tip of the nib lets out just the tiniest amount of ink, creating a delicate thin stroke. These strokes that are the hallmark of modern calligraphy.

The main differences between nibs are the flex and the size. A medium-flex nib is preferable for beginners as it is more forgiving while you learn how much pressure to apply without creating huge inky strokes. The most common starter nib is the Nikko G. This is the nib that I use for all my workshops and in my kits. It is also the nib that I personally use most of the time as I naturally have quite a heavy hand and I find the

Nikko G has the perfect amount of flex. It is quite a large nib, which means that it holds more ink so you don't need to dip too often – again something that is handy for beginners.

Once you are comfortable with using a nib, it is a good idea to try out a few different types until you find the perfect nib with the ideal amount of flexibility to suit your style. Some people don't apply much pressure, so a more flexible nib is best, whereas others apply more pressure and something with less flex is preferable. Some popular nibs include: Brause 361 Steno 'Blue Pumpkin', Hunt 101, Gillott 404, Gillott 303, Leonardt EF Principal and, for the very confident, Brause EF66 is a lovely little nib. Bear in mind, though, that this nib is extra small and won't fit in all holders. When nib shopping, choose nibs that are for modern or Copperplate calligraphy.

It is also useful to keep a variety of nibs for different jobs. For a project that requires small calligraphy, a small, harder nib is usually a good choice since you

don't want thick lettering, which would take up too much space. For something larger, choose a bigger, more flexible nib. Bear in mind that it might take a while to get used to a new nib. If it doesn't feel right straightaway, try practising some drills and basic shapes to familiarise yourself with the new tool. Ultimately, use what you are most comfortable with.

Nib Care and Storage

During calligraphy sessions, it is a good idea to clean your nib occasionally to stop the ink from drying on it, and prevent it clogging up the vent and spoiling the flow. I keep a small glass of water on my desk and swish my nib in it every now and then. Whenever you change ink colour or finish a project, make sure you clean and dry your nib thoroughly. Remove the nib to clean it as the ink can sometimes seep into the groove of the pen holder, which could contaminate the next colour you use (total nightmare if you're going from black to white!), and also, over time will dry, and your nib will get stuck in the pen holder – I keep a pair of pliers on standby for these scenarios. Clean the nib in water then dry it off with kitchen paper, which is better than tissue as it is less fibrous, so won't cause tiny fibres to get caught in the nib. It is important to dry nibs thoroughly as they are metal and can easily rust. I keep all my spare nibs in a little tin with some silica beads – the kind you get when you buy new shoes or a handbag – which absorb water, to keep the nibs rust-free for longer.

Over time, the point of your nib will wear down and will need replacing. How often depends on how regularly you use it and the type of materials you write on. You will find that, in general, your nib feels different and your thin hairline strokes will start getting thicker as the point becomes blunt. I always keep a supply of my favourite nibs in stock so that I don't find myself stuck with a blunt nib and a ton of calligraphy to complete!

INKS

There are so many inks on the market for dip pens that, as with the nibs, it is worth getting a couple and trying them out to see which you prefer, but to start with I recommend getting some Higgins Eternal ink. This ink is wonderfully black, flows perfectly and dries quickly – essential when you are doing pages and pages of practice. With Higgins, I find that by the time I have finished my second page of practice the first page is dry enough for me to put it on top of. Another very popular ink is Sumi ink, which originates from Japan. While this ink is lovely and has a beautiful sheen to it, I find that it takes a long time to dry, which doesn't make it ideal for me. However, it is definitely worth trying as you might find that it suits you better. Basic black ink is all you need to get started, but we will take a look and making your calligraphy brighter with more colourful inks later in the book.

PAPER

Unfortunately, you can't practise calligraphy on any old notepad. You need good-quality paper, otherwise the ink will bleed everywhere. For starters, I suggest a Layout Pad or Rhodia Pad. Out of the two, Rhodia is my favourite, but both are great options. Their paper is smooth and quite thin, so you can add guidelines or place a design underneath to trace, which is great for both practice and planning out designs. I do all my prepping and practice on Rhodia paper, as well as any spot calligraphy that I need to scan at some point.

Choosing paper for handwritten projects can easily become a bit of a minefield. It is really about lots of experimenting and testing. Don't buy hundreds of sheets of anything until you have tried it first. The general rules for choosing paper are that you want it to be smooth, to stop your nib from snagging, and uncoated (the ink can just sit on the surface of coated paper). My go-to paper for place settings, envelopes and anything handwritten is Colorplan by GF Smith, an uncoated paper that comes in a variety of colours. It has a bit of texture to it so you need to be fairly confident with your calligraphy before starting to use it – definitely not one for practice. Hot-pressed watercolour paper is also a great option for hand-drawn pieces. Use acid-free if you can, so the paper stands the test of time.

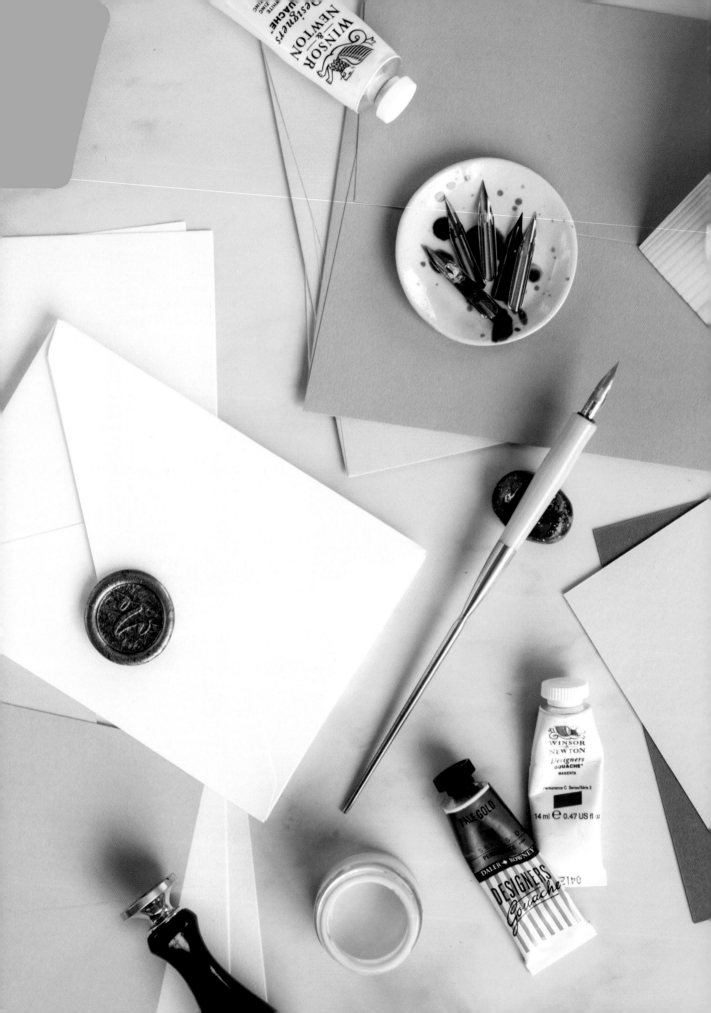

Once you've bought and read how to use all the basic calligraphy tools, you will be ready to begin. As you progress and become more confident with your calligraphy practice and projects, it will be useful to keep some of the following items to hand.

GUM ARABIC

Gum Arabic is a natural substance made from the sap of acacia trees. It is edible and used widely in the food industry. In calligraphy, we use it mainly in mixing inks or as an additive to ready-made inks. It can also be used as a binding agent (making the ink stick to the paper), as a thickener for more watery inks, to add luminosity to inks that might dry a bit chalky, or to stop cracking of inks that dry out a lot on paper. We will talk more about Gum Arabic later, when we look at making coloured inks. You can buy Gum Arabic in liquid or powder form; I tend to use liquid for ease.

KITCHEN PAPER AND WATER

As touched on earlier, it is a good idea to keep a little pot of water nearby for cleaning your nibs and kitchen paper (not tissue) for drying them – also great to have to hand in case of any ink spillages!

DRYING RACKS

As desk space can quickly run out when you are creating lots of envelopes or place settings, drying racks are perfect little space savers. (I use plastic ones from a Gocco screen printer that I used to own and you may find kicking about on eBay.) You can also find handmade wooden racks on Etsy, or you can get inventive and use an old wire CD rack or toast rack!

LIGHTBOX

A great piece of kit, a lightbox is an illuminated surface that helps you to see through paper to enable you to trace over any mock-ups you might have done of layouts etc. before doing a handmade piece. I suggest an A3 lightbox but you can go smaller if space is an issue.

LASER LEVEL

A laser level is a tool used in DIY and is used like a common spirit level to check surfaces are straight. It shoots out a laser beam in a dead straight line, making it perfect for temporary guidelines that you don't have to go back and erase. It is not the first thing you would expect to find in a calligrapher's studio, but is a very important hack nonetheless and will save you hours drawing out pencil lines to keep your work straight and then erasing them afterwards. Instead, mark out your spacing on the side of the paper then use a laser level to create a moveable straight line.

EMPTY JARS

These are useful for decanting big pots of ink into, or for making your own inks in. You can buy 15ml mixing jars online and from apothecaries, or use mini jam jars. Look out for 15–30ml pots.

PAINT AND PAINTBRUSHES

Something we will discuss further in the Mixing Your Own Inks section (see pages 54–55), these are used to mix inks and are also great for adding any hand-painted details to your work.

PENCILS AND PENS

Pencils are essential for planning out work and practising any tricky shapes, without focusing on a nib. My favourites are Palomino Blackwing pencils, but any selection of artists' pencils with varying hardness will do the job! We will use various pens for the projects in this book but, as a general rule, paint markers, such as Uni POSCA Markers (water based) and Sakura Pen-touch (oil based), are excellent, and fineliners are great for faux calligraphy and illustrating.

ERASERS

A good-quality pencil eraser is essential for general erasing and pencil mock-ups. A sand eraser will help get rid of some tiny mistakes and smudges.

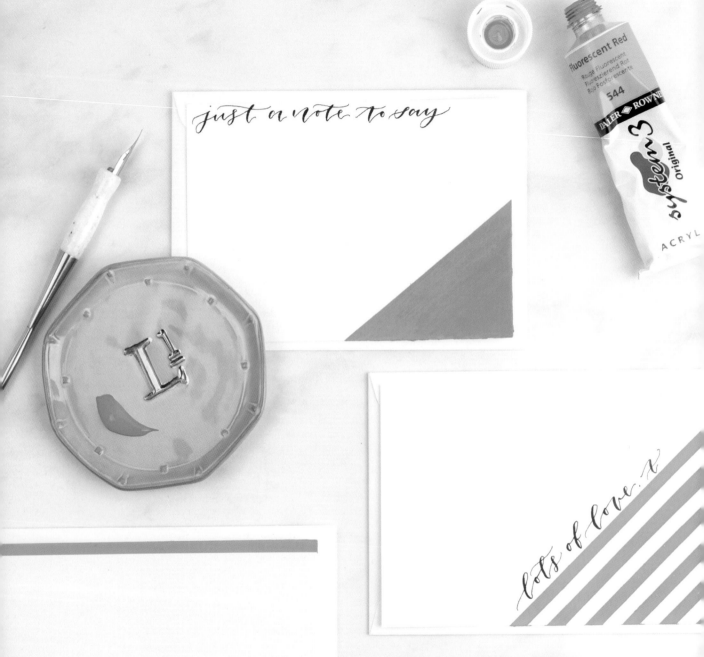

get writing

Roll up your sleeves – it's time to get writing!

Once you have been shopping and bought all the tools
that a new calligrapher needs, you're ready to start practising
exercises and letterforms.

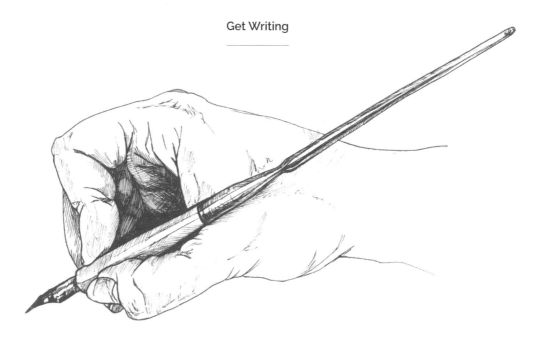

GETTING STARTED

First things first, whenever you buy a new nib it will have an oily factory seal on it to stop it from rusting. While this oil protects it from water, it also prevents it from holding on to ink properly, so you will need to get rid of the oil before using the nib. There are a few ways of doing this:

Toothpaste
Squeeze a tiny amount of toothpaste on to your finger and rub it all over the nib, making sure you cover the front and back. Then, rinse it off under running water and dry thoroughly with kitchen paper. You can use an old toothbrush to scrub the toothpaste over the nib if you have one.

Potato
Stick your nib point first into a potato. This will break down the nib's oily coating. Remove the nib after about 10 minutes, rinse and dry it thoroughly.

Flame
Quickly pass your nib through the flame of a match or lighter a couple of times. Make sure you don't get the nib too hot as, being metal, it will change shape.

Washing-up liquid and warm water
Pop your nib into a little cup of warm water (not boiling) with a splash of washing-up liquid, and leave for a few minutes. A quick scrub with an old toothbrush will also help to remove the oil. Rinse and dry the nib thoroughly.

PREPARING YOUR PEN HOLDER
Most nibs are a standard size and will fit inside the standard pen holders that I recommend in the Tools chapter (see pages 14–21). There are, however, a few small nibs that need special holders. You can buy these online and you will find recommended websites at the back of the book. The nib insert can vary, but most pen holders have a universal insert, with four little prongs in the middle, which suits most calligraphy nibs. Slide the nib into the outside groove, below the rim (so the prongs are on the inside of the nib). Plastic pen holders, such as the Speedball, have a plastic groove for the nib to slip into; these are great for standard size nibs, such as the Nikko G, but won't fit smaller nibs. When inserting a nib, make sure that half of it sits in the holder. With the Nikko G, the end of the holder should sit near the 'G' on the nib.

To hold your pen, you should rest it in your hand rather than gripping it, so your hand is just guiding the pen. Grip the pen between your fingers wherever feels most comfortable, but try not to grip too high up as this won't give you as much control. Most pen holders have an ergonomic design, with a thinner section to indicate roughly where to hold it. The pen should rest between your thumb and forefinger. The nib needs to be flat to the page so that when you apply pressure it is equal on both tines (prongs). Holding the nib at an angle puts an uneven amount of pressure on to one tine, forcing the tines to cross over and hit each other.

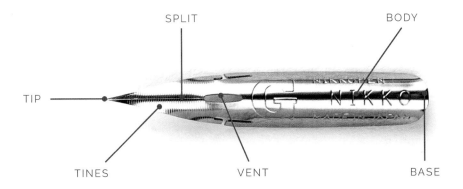

TIP

SPLIT

BODY

TINES

VENT

BASE

INKING YOUR NIB

When dipping your nib in the ink, check the vent is full before you take it out otherwise you will run out of ink very quickly. Carefully wipe the back of the nib on the side of the inkpot to get rid of excess ink. To create the thin and thick strokes, which are paramount to this form of calligraphy, you change the amount of pressure that you apply to the nib. When going down, you want to form a nice thick downstroke by putting pressure on the nib and opening up the tines to let lots of ink flow through the split on to the paper. The more pressure you apply, the more ink will flow. When going up, you want a delicate, thin upstroke; by releasing the pressure, the tines return to their original position and the tiniest amount of ink on the tip of the nib makes a hairline stroke. When changing from thick to thin or vice versa, take the curve slowly, making sure that the change is smooth and gradual. You don't want your thick stroke to suddenly end and a hairline to begin as this will not look purposeful and clean.

Due to the nature of a dip pen you will have to keep re-dipping your nib into the ink during your calligraphy session. The frequency at which you do this is dependent on a few variables – mainly how much pressure you place on the nib. If you keep an eye on the vent as you write, you will notice it emptying. It is good practice to re-dip before you totally run out of ink and to do it at the end of a letter or, even better, a word. If you run out mid-letter then it is preferable to re-dip on a thick downstroke as these are easier to rejoin and pick up again. Joining a hairline stroke is always a bit tricky.

WRITING TIPS

1. Don't rush it. Calligraphy is meant to be a relaxing activity. Going slowly will mean you stand a better chance of perfecting your letterforms and will give you more control.

2. Keep your grip relaxed and remember that you are just guiding the pen. This will not only help your calligraphy but will also prevent you getting cramp.

3. Write with your entire hand, not just your fingers. Using only your fingers to write will mean that you will have to keep stopping and starting as there is only so far that they can stretch, meaning you won' t get flowing letters and words.

4. Experiment with the angle of your paper so that your hand is comfortable and consistently holding your pen and nib in the same position, while at the same time enabling you to control your shapes. Your nib must stay in the same position, whether you are doing an upstroke or a downstroke. Don't be tempted to change the angle of your hand when you do different strokes or else you won't be able to get a nice controlled flow to your calligraphy.

5. Get comfortable. Sit on a proper chair at a table. Don't attempt to do your practice on your lap in front of the television. It won't work. Sit with your back straight and make sure you have lots of space for your arm to move freely as you write.

DRILLS

Now you have all your tools ready and understand the basic workings of the nib you are ready to have some fun with drills. When taking up calligraphy it is imperative that you learn to walk before you run or you'll risk getting frustrated with your progress and giving up. The following drills are not only essential to learning but are also useful as a warm-up, whatever level you're at. If I'm sitting down to start a large handmade order then I always make sure I complete at least half a page of drills first. Drills may not be the most exciting part of calligraphy but are essential to enhance performance. Repeating these exercises over and over again will build up muscle memory and prepare you for the fun letter writing to come. The more confident you are with drills before you move on to letterforms, the easier you will find the letters.

To begin with, if you find it easier, place your layout paper over the opposite page and trace over the drills a couple of times to get used to the shape and then try them freehand. Next to each drill exercise you will see a little arrow showing the direction in which you should go. Experiment with the amount of pressure you apply – now is the time to get used to your nib. Don't worry if your lines are a bit wobbly – more control will come with practice. The main goal at this point is to have clear differentiation between your thick and thin strokes and for the change to be seamless and controlled. You don't want your thick stroke to end suddenly and a thin one to begin – the thick should instead lead into the thin as a result of you gradually releasing pressure.

NIB PRESSURE
Remember, on downstrokes you need to apply pressure to open up the nib for lovely thick strokes. For upstrokes, release the pressure so that the point of the nib only lightly skims the page in order to form delicate thin strokes.

When changing from thick to thin strokes, go slowly and reduce the pressure gradually to achieve a clean-looking curve.

Apply pressure on the downstrokes for a thicker line

Lift the pressure on upstrokes for a finer line

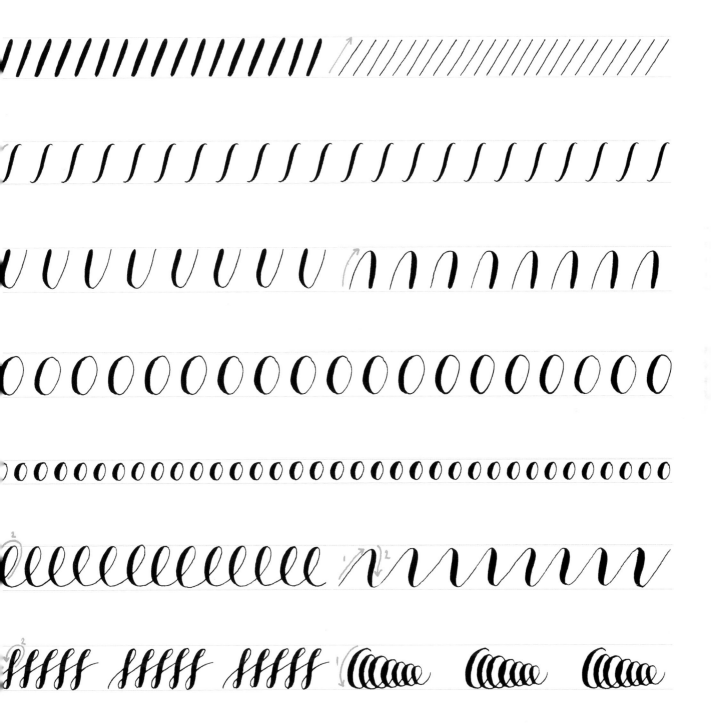

CALLIGRAPHY DRILLS

THE ALPHABET

Once you have mastered the drills, it is time to have some fun with the alphabet. On the next few pages we will look at the way that letters are formed, drawing on the shapes you have been practising in the drills. The following alphabet is in my standard style. Focus on copying this for the time being. You can create your own style later, once you are confident with the letters. You might find that you have a natural style from the get-go; maybe your letters are a bit curlier than mine or flick off with more pizzazz… Embrace it. This is what makes your calligraphy unique, which is ultimately the goal.

When getting to know the alphabet, it can be useful to trace over the letters a couple of times to become used to the shapes and where to apply and release pressure. Just remember not to trace forever. You need to try it freehand in order to build up confidence.

If you find particular letters tricky then break them down into shapes and focus on the single shapes rather than the whole letter. Sometimes it can be just one curve that is throwing off the whole letter. If you get a pencil and go over and over that curve it will build up your muscle memory so that when you try to write the whole letter with a nib you should find it easier.

For practice, it can also be useful to group together letters that are made up of similar shapes, such as uppercase 'B', 'D', 'P' and 'R'. Familiarising yourself with one group of similar-shaped letters before moving on to the next can prevent all the different shapes from becoming overwhelming.

Remember that practice makes perfect – no one picks up a pen and nib and is magically able to do calligraphy. Practise little and often and I promise you will get better.

REMEMBER
1. *Go slowly.* Calligraphy is meant to be a relaxing activity and it isn't a race. The slower you go, the more control you will have over your curves and shapes.

2. *Loosen your grip.* You are guiding the pen not forcing it to do what you want.

Cc Dd Ee Ff

Ii Jj Kk Ll

Oo Pp Qq Rr

Nn Vv Ww Xx

1 2 3 4 5 6 7 8 9 0 & ! ?

While everyone takes time to get used to using a dip pen and ink, there are some common mistakes that might hinder your progress as you practise.

HOLDING THE PEN TOO HIGH

The pen should be resting against your hand between your thumb and index finger, not straight up as you would hold a ballpoint pen or pencil. Holding your nib upright won't enable the tines to open and it will be very scratchy as all the pressure will be on the tiny little point of the nib. Try relaxing your grip and lowering the pen so it is roughly at a 45-degree angle to the page.

HOLDING YOUR NIB AT AN ANGLE TO THE PAGE

You want to write with the nib flat to the page so that the tines can open up and release the ink to create lovely thick strokes. If you hold the nib to the side when you apply pressure, the ink will all be on one side and the tines will hit each other. This will stop the tines from opening and will potentially cause them to catch and flick ink everywhere – less than ideal. Without using any ink, play around with the position in which you hold the nib, and add pressure to check that the tines are really opening up.

INK DRAGGING WHEN CROSSING STROKES

Some letters, such as uppercase 'A' and lowercase 't', have a stroke that goes across the letter. Now and then, you may get some ink dragging when you make this stroke. This can be because there is excess ink on the original stroke or because you are applying too much pressure. The stroke should be very light and delicate, with almost no pressure, like an upstroke. If you are still getting drag, even with minimal pressure, then it is probably because of the amount of ink on the paper. There is nothing wrong with that at all, I tend to not do my cross overs until the end of the line or at least the word, so the ink on the main strokes has a chance to dry and there is less chance of drag.

CHANGING HAND POSITION

Your hand should be in the same position, whether you are doing an upstroke or a downstroke. It can be tempting to change the angle of your hand when doing an upstroke as the tines don't need to open, and you might feel that coming from the side will give you more control. The problem with this is that when you start bringing the strokes together and creating letters and words, your strokes will not have a continuous flow to them if you keep stopping and starting to change your hand. Although it may feel uncomfortable at first, keep your hand in the same position and concentrate on drills until it starts to feel more natural. Experiment with the angle of your paper to find the best position for you to keep. I tend to write with the paper at a right angle to my body.

NO DEFINITION BETWEEN YOUR THICKS AND THINS

This is what drills are perfect for – refining the amount of pressure that you put on your nib for different strokes and changeovers. If you find your letters are lacking definition, go back to the drills, check your nib is in the correct position, so the tines can open fully, and experiment with the amount of pressure you apply to your nib. Personal preference plays a part in how thick you make your strokes. Some people like to have a lot of difference between their thick and thin strokes, whereas others want only a little difference. It is all about playing around and finding what suits you best.

INK BLEEDING

At the practice stage, ink bleeding is probably happening because you are using the wrong paper. For practice and anything that you are going to scan in (i.e. not a handmade item), layout paper or Rhodia pads are best. If your ink is bleeding on paper that you are going to be using for a final piece, there are a few tricks that you can try with the ink (see page 55, Troubleshooting with Different Inks).

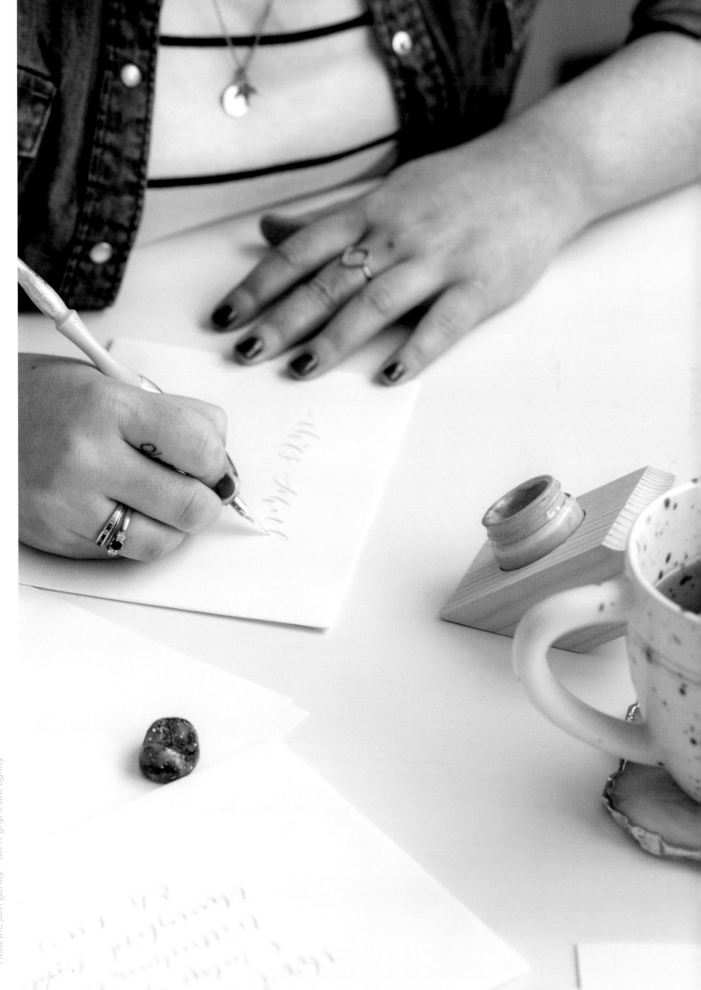

JOINING LETTERS

It is really important to focus on writing single letters before moving on to joining them up to make words. Once you are comfortable with single letters, you will find the connections between them much easier to navigate. The key to joining letters is to go slowly, and try to think about the ways in which the letters work with each other before trying to join them. As tempting as it is, don't jump into trying to write your name.

common letter pairings
First, look at common letter pairings and practise them on their own, just two letters at a time rather than concentrating on a whole word. If you find this tricky, sketch them out in pencil first, trying a few different ways to see what works best:

double letters
There are some letters that are commonly found doubled up next to each other. These can seem a little trickier as you want them to sit nicely together, not be fighting each other for space in a word. As my style tends to be quite bouncy (i.e. letters don't all sit on a baseline), I tend to lower one of the double letters or make one larger than the other:

popular words
Once you are feeling comfortable with pairings of letters, move on to some simple words. Take your time and don't get frustrated if something doesn't look right. Analyse it and try to work out what's wrong, then try again, in pencil if need be. It might just be one connection that is throwing the whole word off, in which case take those two letters out of the word and practise that connection on its own, as you were doing at the start. Once you feel better about it and it looks right, try the word again:

uppercase joins
As you may have noticed, my style tends to be all lowercase, so my letters are usually all joined. However, when I use uppercase I don't tend to join them to the rest of the lowercase letters. There are some letters that I do join, for example 'P', as I like how it looks, but if a connection doesn't feel natural then don't force it or your calligraphy will end up looking unbalanced:

the quick brown fox jumped over the lazy dog

PANGRAM

Don't worry, this whole thinking out every single join process is not forever. The more practised you become at making connections between letters, the more they will become second nature, and you will be able to write whole words, sentences and paragraphs without thinking about them. Pangrams (sentences containing every letter of the alphabet) are also a great way to practise joining letters. A popular pangram to try is: 'The quick brown fox jumps over the lazy dog'. As this sentence includes every letter in the alphabet, you will practise some uncommon letters, such as 'x' and 'z'.

REMEMBER

1. Slowly does it. Don't rush your connections, go slowly and give yourself time to think about how the letters are working together.

2. Relax. The tighter you grip the pen, the harder you will find it to get a smooth, controlled flow to your words and letters.

3. Re-dip. You will be used to re-dipping frequently by now, but remember to keep an eye on the vent in your nib so you can re-dip before totally running out of ink. Try to re-dip either at the end of a letter or word or, if you can't make it that far, on a downstroke. Thick strokes are a lot easier to pick up than thin ones.

4. Pencils for planning. If anything looks dodgy or is stressing you, try it in pencil first. This helps you to just think about the shapes and joins without worrying about what your nib is (or isn't) doing.

PROPORTIONS

Within typography, there are certain rules surrounding letterforms and the relationships between the different shapes that make up the letters. This is exactly the same for calligraphy and, while my personal style of modern calligraphy does not always stick precisely to these rules, it is important to understand them before breaking them. Sometimes, a small tweak to the proportion of your lettering can change the whole feel and legibility of it, so it is important to take note of these basic rules before then moving on to create your own style.

GUIDELINES

When starting to practise, guidelines are useful for helping you to get the proportions correct and consistent. If you stick to using these until you are confident with your letters it will give you a great basis, and help you to define a style that, though it may not stick to a rigid format, will look proportionate and legible.

Guidelines for modern calligraphy are most commonly based on Copperplate guidelines, which use an ascender to x-height to descender ratio of 3:2:3. Normal x-heights are usually 4, 5 or 6mm. Therefore, if you are using a 4mm x-height, you will have 6mm descender and ascender lines. You can see an example below of how the proportions of our letterforms fit into these guides, although here they have been blown up much larger.

FAUX CALLIGRAPHY

Sometimes, due to the materials or scale of work, calligraphy with a nib isn't possible. In these instances you can use other tools to create faux calligraphy. Faux calligraphy uses a normal round-tipped pen instead of a flexible nib to recreate the thick and thin strokes of calligraphy. You do this by first writing the word out and then going back over the downstrokes, making them thicker. Faux calligraphy is particularly useful when creating large-scale signage or projects on non-paper surfaces.

MONOLINE CALLIGRAPHY

For monoline calligraphy, you use a paint pen, and leave the downstrokes as single lines rather than going back over them. This can be particularly attractive on objects such as baubles and plant pots (see pages 146–9 and 134–5). It is completely down to personal taste as to whether you use faux or monoline calligraphy for different projects. Personally, I like to use faux calligraphy on larger pieces, such as wooden signage, but stick to monoline for smaller objects, such as shells and baubles.

ASCENDER

X-HEIGHT

DESCENDER

LETTER PROPORTIONS

Ascender – this is where the high strokes of your letters will come up along with the total height of your uppercase letters.

X-height – this is the height of your standard lowercase letters – measured by the lowercase 'x'.

Descender – this is where the low strokes of your letters will drop belo

calligraphy

calligraphy

FAUX CALLIGRAPHY

you've got this

MONOLINE CALLIGRAPHY

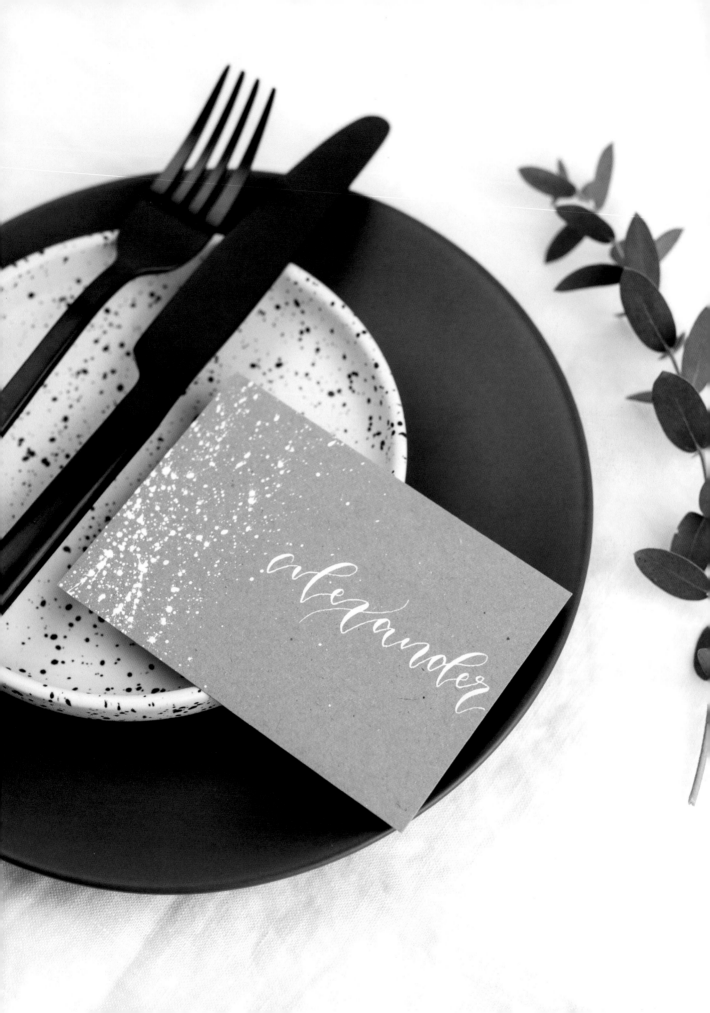

introducing some Style

───── **CHAPTER THREE** ─────

Using your new skills to create your own style.

Once you are comfortable with the letters shown in the Writing chapter,
and joining them to make words, it is time to start developing your own style!

The process of developing a unique style is creative and lots of fun. The beauty of modern calligraphy is that you can, within limits, do what you want and call it your own. Don't worry about getting it right first time. Take it slowly and embrace all the little quirks of your lettering. If your letters naturally curl round at the ends, then make something out of that. If you have a spacious, flowing lettering style, then work to perfect that. Think about what you do naturally and what you like, then mix it all together.

As well as analysing your own lettering, take inspiration from other calligraphers, hand-letterers, and digital typefaces, to see how the letters and connections work together. By drawing on these influences and mixing them together in a way that works for you, your unique style will soon begin to emerge.

On the opposite page you will find a few different ways that you can begin to experiment with your calligraphy that will, hopefully, start you off on your journey to finding your style.

HOW MY STYLE EVOLVED

Even after six years of doing calligraphy my style is still evolving. The foundations are there and largely stay the same, but I make small tweaks to the shapes of my letters all the time. Sometimes I just go off a style or find that I naturally write a certain letter in a different way now so it becomes part of my style. I sometimes look back at work that I did a year ago and dislike it intensely. In general, my style is fairly upright, bouncy and open (as in my letters don't always meet up). It is also, 90 per cent of the time, all in lowercase. I have always preferred the lowercase alphabet, and when I first started practising calligraphy I found uppercase letters much harder to write, which is why I avoided them for years. I don't find them tricky any more, but my style favours mainly lowercase.

Some calligraphers have a variety of styles that they are masters at. I only have one, but there are variations within that, depending on the brief. I can formalise it, add a slant or more space between letters to suit different jobs, and I also go through phases of liking different things. Sometimes, my style might be very spaced out with long entrance and exit flourishes. Other times, it is more upright and bouncy. It really depends on my mood and what I am being asked to do at the time, and I tend to roll with it rather than pushing myself to do something that just doesn't feel natural.

When I first started calligraphy, I got very hung up on loose, floaty, delicate styles and tried to recreate them, but I have a heavy hand and I just can't do delicate. It used to frustrate me, but gradually I realised that I needed to embrace where my style was naturally taking me, and make that mine. While I still look at delicate calligraphy with heart-shaped eyes, I no longer aspire to that. I now know that it is not for me and that my style fits with my personality and brand perfectly because it isn't forced. Its evolution has happened organically and that is exactly how it should be.

STYLE EXPERIMENTS

COMPOSITION & LAYOUT

By now you are probably chomping at the bit to start making things. You might already have some projects and plans in mind, but it is important to first consider the composition and layout of your artwork to make sure it will be visually pleasing and balanced. For most projects, I plan designs out in pencil first, which makes me less precious about what I am doing, and my pages quickly become filled with creative scribbles. I then pull out the designs and ideas that I like best and start to ink them up. Work in black and white first, as this can make it easier to get the composition right.

The main thing when using your calligraphy in a design is controlling how the different letters sit together; each letter and word needs breathing space. You don't want things bumping into each other and fighting for space – it will be confusing to read and distinguish and your work will look cramped and messy.

HIERARCHY
Distinguish what words in your piece are the most important. For a wedding invitation, it will be the names of the bride and groom, for a greetings card, the sentiment you wish to send, and for a long quote, there might be specific words that you want to make jump out. Once you have chosen the main words, the rest of the design should fall around them. Make the main words larger and give them space. Not so much that everything else is tiny and cramped, but enough so that the reader or viewer can instantly see what is most important.

SPACING
Your lettering needs space to breathe. By the very nature of calligraphy it can be harder to read than, for example, a font on your computer. The eye needs time to distinguish the letters and read the words, which is very difficult if everything is all cramped together. Your lettering should flow from word to

word, not be fighting for space between the last letter of one word and the first letter of the next. Leave plenty of space between the lines for ascenders and descenders – you don't want them to be bumping into the letters above and below. Don't be scared of white space; use it around your lettering, especially if it will be framed. If your work is going into a thick frame, leave more space around the design, so it won't be fighting for attention with the frame.

BALANCE
Designs are more visually pleasing when they are well balanced, so I tend to centre most of my work. Left-justified lines can make the whole design feel a bit uneven. You want to try to make your line lengths even(-ish) or, if not, have a balance of short and lengthier lines. For example, one short line with two words on and then six long lines with 10 words on will look odd. This is where planning in advance of inking helps as you can check line lengths and have a little rejig if need be.

COLOUR
When you are happy with the composition, you can begin to experiment with colour. You can buy or make calligraphy inks in any colour and you can also use coloured card, so there are many possibilities when creating a colour design. Decide what mood your piece will convey and work with a colour palette to suit that. If you are writing a quote about the sea, for example, then you don't want to write it in shocking pink, and likewise, if you are writing lyrics from a punk rock song then seaglass green probably isn't the best match. Check that your colours don't clash and, if you are using a dark card stock, make sure your ink is opaque enough to stand out once dry.

S R

TOGETHER WITH THEIR FAMILIES

Sarah

barr

AND

robert

Speed

ARE DELIGHTED TO INVITE YOU
TO THEIR WEDDING

11.08.2018

2PM, THE BARN AT BURY COURT,
BENTLEY, FARNHAM, GU10 5LZ

FOLLOWED BY A WEDDING BREAKFAST AND RECEPTION

A WEDDING INVITATION COMPOSITION

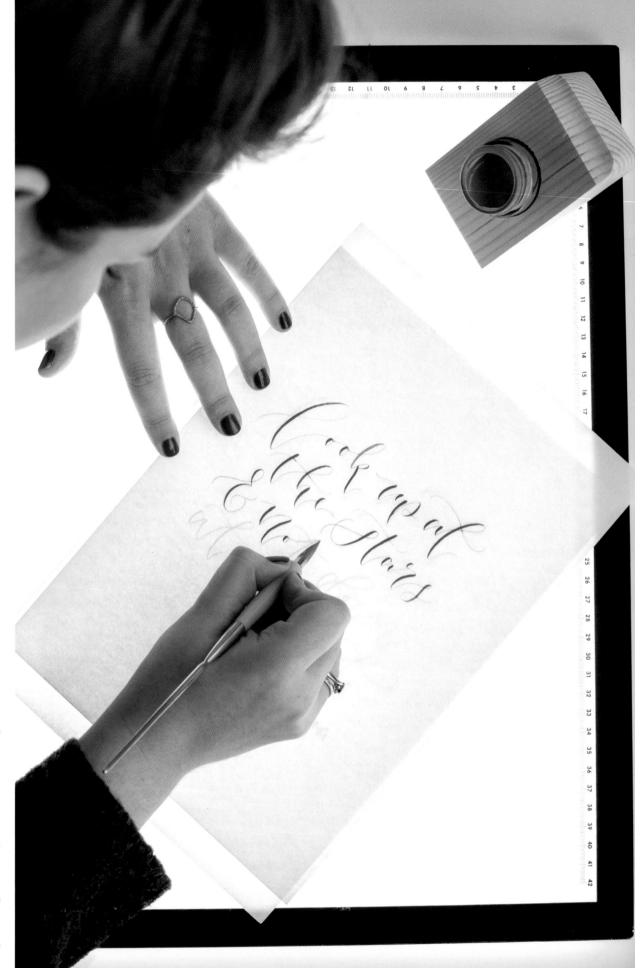

When you are starting out, unless you have a background in design, you may feel a bit freaked out about producing any digital work. The great news is that there are plenty of things that you can do entirely by hand. Just take a look at all the projects in the Projects section (see pages 56–155).

PAPER AND CARD

Choosing the correct paper and card can be a bit of a minefield. There will be a degree of testing needed, as what works for me might not necessarily work for you, but there are a few general rules and brands that should make your experimenting quicker and easier!

As discussed before, you want your paper to be smooth and uncoated. These are the two main things. You need it to be good quality so it withstands the ink and, if it is for an original piece of work, not too thin. I recommend 120gsm at least, and for greeting cards, tags, etc. about 270 or 350gsm. My favourite card stock is Colorplan by GF Smith. It comes in a large variety of colours, which are great for matching up to specific projects, and while it has a bit of texture to it, it doesn't snag my nib or wear down quickly. I buy it directly from the paper merchants if I just want flat sheets, or from online retailers if I want different formats, such as prefolded cards, tags, envelopes etc. Another card stock that I recommend is Canford by Daler Rowney, which is smoother than Colorplan so a bit more suited to a complete beginner. It comes in a variety of colours and is readily available from art stores. Good-quality watercolour paper is also great for calligraphy – again opt for the smooth variety (hot-pressed tends to be smoother).

If you have a specific paper that isn't working with one ink there are a few tricks you can try (see page 55, Troubleshooting with Different Inks), for example using a gouache mix tends to bleed less than ready-made ink such as Higgins.

TOOLS

The most important tools when creating handmade work, aside from your pen and ink, are a trusty pencil and scrap paper. Sketching and planning everything out before you start will save lots of inky mistakes on expensive paper. Once I find a layout or design that I am happy with, I sketch it at the size and proportion that I want for the final layout. Then, using a lightbox, I trace over the sketch in pen and ink. The beauty of using a lightbox is that you can tweak your work to what feels natural when using a nib. My pencil and ink versions always differ slightly. I do the same with pen illustrations, using a fineliner to trace over the original pencil sketch.

DARK PAPER

Working on dark paper can be a bit trickier because you can't use a lightbox for tracing, as the light won't shine through, unless your paper is very thin. The solution is to use a soapstone pencil to mark out the lettering directly on to your card. Soapstone pencil is white so shows up clearly on dark card. It also erases easily. Therefore, once you have inked your design and left it to dry fully, you can simply erase the soapstone guidelines.

As already discussed, you can do many things with calligraphy without touching a computer. It is a handwritten art after all. But if you want to take your designs to the next level and start to integrate them with typed fonts and digital artwork then here is a brief overview of how I digitise my lettering. This is the way I learned it years ago and have always done it. It may not be the 'right way' but it has always worked well for me. There are lots of different ways of getting the same outcome and many useful resources available.

TOOLS

For digitising, you'll need a couple of tools – a scanner and a computer with design programs. The scanner doesn't have to be an amazing one, just something that scans at decent resolution. For reference I scan at 600dpi. If you don't have a scanner but you have a phone with a decent camera then you can just snap a picture. It won't be as clean and you are more likely to get shadowing, but it will be high-enough quality to edit and clean up.

I use a Macbook Pro computer with the Adobe Creative Suite, in particular Photoshop, Illustrator and InDesign. You do not necessarily need all of these programs – there are lots of designers I know who only use Photoshop or Illustrator, and there are also other options for image editing – but this is the way I do things.

CREATING VECTORS

I like to work with vectors of my calligraphy, which means that I can resize them without affecting the quality of the image. As I generally work with artwork that is A4 or smaller, this isn't actually particularly necessary but I am a creature of habit and I have always done it this way. I use the following process to create these vectors:

1. *Scan in your calligraphy* as a black-and-white image at 600dpi and open in your editing program, such as Photoshop.

2. *Once open in Photoshop* get rid of anything in the scan that you don't need by erasing or cropping.

3. *Make sure your file is black and white* (convert to grayscale if not) and adjust the contrast to 100 per cent. Then, using the levels palette and the

eyedropper, get everything either really white or really black, paying special attention to the grey pixels that sit around the calligraphy.

4. *Clean up the background* using a paintbrush, eraser, or one of the selection tools in your program. Take care not to nibble into the calligraphy – the aim is to create a clean outline, ready for tracing.

5. *Trace the outline to vector.* I use Illustrator for this. First, make it really big, larger than the artboard, and then using 'live trace', trace your calligraphy. The settings for the 'live trace' will depend on what version of Illustrator you are using and will need tweaking. Some guidelines for your settings are: having the threshold at about 100; a low path fitting; strokes turned off; and always ignore white or you'll end up with odd filled-in bits.

6. *Now you need to expand it,* to get the outline from the traced image. Save your file in a format that you can use in your layout program, such as a .eps or a .pdf. You can use Illustrator to design the whole piece, but I sometimes use InDesign for more control over the layout.

LARGE-SCALE WORK

Using 'live trace' is ideal when you are working on a small scale but if you are printing really large or, for example, having laser cutting done, then the edges will be too bumpy just using 'live trace'. For smooth lines, use the pen tool in Illustrator to completely trace, or use 'live tracing' and then go in and manipulate all the little points on the paths to create a smoother line. This takes a lot of patience and practice but is worth it.

RESOURCES

When I started to digitise my work, I had some previous knowledge of design programs, but I learned the process explained above from an online tutorial on Skillshare. It is much easier to learn through watching rather than reading instructions, so if you want to understand digitising then I recommend searching on learning platforms, such as Skillshare or YouTube, where you will find plenty of expert tutorial videos. Everyone has a slightly different way of digitising, therefore it's a good idea to watch a few videos to see which you find easiest to follow and which will yield the results that you are looking for.

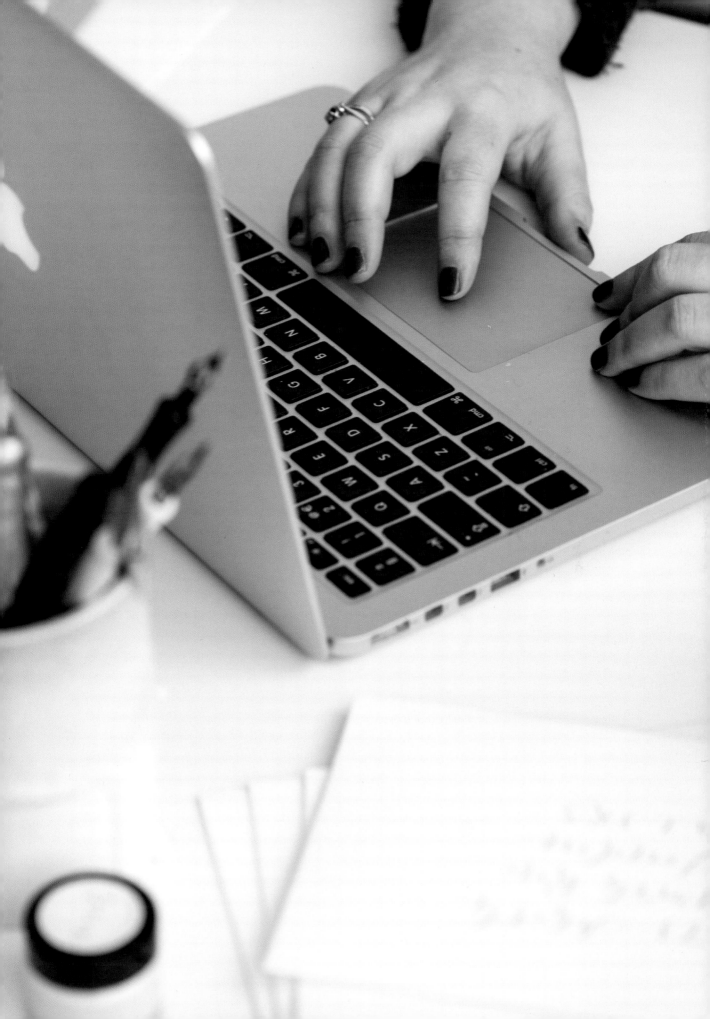

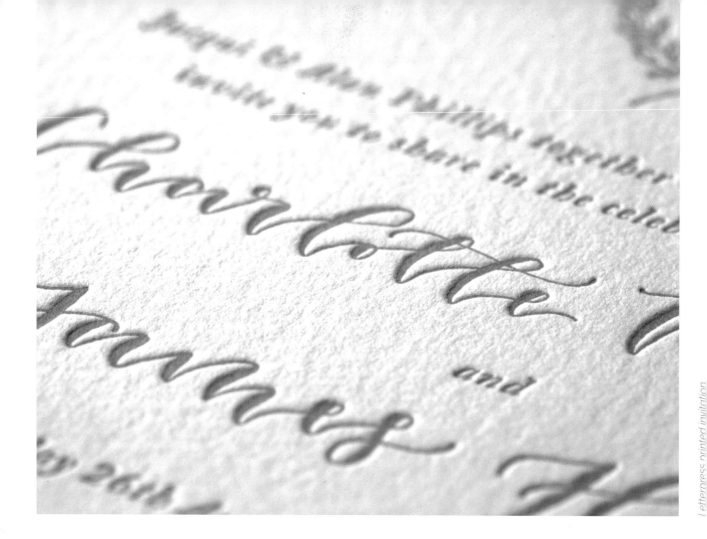

PRINTING PROCESSES

If you have mastered the art of digitising your calligraphy then you may want to get your designs printed. You can of course print at home – many standard home printers will print on to a low-gsm card. However, if you want to have something professionally printed here is a mini breakdown to make navigating printers a little easier.

Commercial printing can be very expensive if you only want a couple of copies of a design. The more copies of something you have printed, the more economical it is. For example, commercial printing would be great for wedding invitations, but not for a single wall-art gift for a friend. There are lots of different printing and finishing processes that I could talk about all day long, but for now I am going to introduce you to the three most common:

DIGITAL PRINTING
Digital printing is the most common and readily available form of printing. It is similar to what your home or office printer does, but on a much larger and higher-quality scale. Digital printing is great for black-and-white or full-colour printing, and can produce high-quality results. You can also have white ink printed digitally on to coloured card stock, which looks amazing. Digital printing is the most reasonable price-wise out of the three processes discussed here, and you should be able to easily find an online or local digital printer.

LETTERPRESS
Letterpress is a form of relief printing, and one of the oldest forms of printing. An inked surface (called a block or form) is pushed into the paper, leaving the most beautiful debossed effect. Traditionally, printing was done using wooden or metal type that had to be set to spell out words, sentences and paragraphs. It was very time-consuming and a true art form. Now, thanks to technology, you can take a digital design in its entirety and get it turned into photopolymer or metal plates that can then be used on the printing press. Letterpress printing can be expensive, especially if you want more than one colour, as you need a new plate for each colour, which is then printed separately.

Hot-foiled invitation

HOT-FOIL STAMPING

Hot-foil stamping is another form of relief printing. It is similar to letterpress in that a design is pushed into the surface of the paper, but this time the block is heated. A foil with a glue backing is placed between the design and paper, which melts upon contact, leaving the foil stuck to the paper. Hot foil always looks great and there is a wide variety of colours and effects to choose from – not just traditional metallic, but also pastels, neons, and holographic effects.

As with letterpress, hot-foil printing gives a luxury finish so is more expensive than digital, but the stunning effects are well worth it.

PREPARING WORK FOR PRINT

Most printers will give you guidelines of how to supply files for printing. Usually, a high-resolution PDF (which you can export from a design program) does the job, but double-check with your printer for any specifics they might need. With letterpress and hot-foil, you will sometimes be asked to outline all fonts and artwork.

FINDING A PRINTER

Your choice of printer depends completely on what you wish to have printed. Search Google for a list of local printers, then phone around them to discuss your needs. For more specialist printing processes you might have to search a little further afield than your local copy shop, but there are plenty dotted around. If you are unsure of anything, such as quality or paper stocks, ask suppliers to send you printed samples.

When I first started Oh Wonder, in 2016, I had a very basic website with a few badly photographed examples of my work. At this point, I hadn't had many calligraphy clients, so most of the work I uploaded was projects I had done for myself. It was a bit embarrassing, but it got me out there and that is what mattered. From there, I started building my portfolio and my business. I am by no means a high-powered businesswoman with a set of rules to success, but I am going to try to impart some useful basic knowledge and tips I have learned, which will perhaps help you turn calligraphy, or maybe another creative business idea, into a successful business venture.

BUILDING A PORTFOLIO OF WORK

At first, when you don't have any paying clients, give yourself briefs to work on. Think of the kind of work that you WANT to be doing, then use that as inspiration. There is no point in filling your portfolio with work that you don't want to do, so have a little think about your dream briefs. Try to make them varied – six variations of the same project is not going to catch people's attention – and don't over-think them. At this point you don't want to overwhelm and stress yourself out, so keep your ideas relatively simple. Take a copy or photo of any odd pieces you do for friends and family as well.

HAVING A WEB PRESENCE

Unless your work is out there somewhere, no one will ever find it. A website enables people to view your work and perhaps, fingers crossed, place an order. Along with being a point of information for customers, it also adds a touch of authenticity to your business.

FINDING THE RIGHT PLATFORM FOR YOUR PORTFOLIO

Whatever your goals are – whether you want calligraphy as a hobby that earns you a bit of extra money or you'd like it to become your full-time job – will have an impact on where you house your portfolio. Instagram is an excellent place to start. You can upload pictures of your work as often as you want, while also getting your name out there and building up a community. You could just use a personal profile that you already have or set up a specific one to showcase your calligraphy work. If you want to have something more professional, then a website is a good option. There are lots of hosting sites available, where you can build your own website around a template (I use Squarespace), or you could commission a professional web designer to build one for you. If you are starting up a more product-based business, then using an online marketplace such as Etsy is perfect. There are plenty of online tutorials on how to make a catchy listing and promote your products to a huge audience.

PHOTOGRAPHY

I am not an expert in photography, absolutely not, but I have picked up some tips on my creative journey. Calligraphy is a visual art and people need to be able to clearly see and understand what you are offering. All the imagery on my website is professionally shot, but I take my own Etsy and Instagram shots with my iPhone. My main tip is to always use natural lighting whenever possible. I take all my photos by my studio door in the middle of the day when the light is good. I tend to keep my photo styling very simple. I may throw in a ribbon or pen, but generally it will just be my piece of work against a lovely background. If using props, take care not to overcrowd the frame. Remember that the hero of the image is your work, so don't place anything in the frame that will take attention away from it. I also edit all my photos on my phone with the VSCO app. Keep product listing shots very simple, showing only what you are selling, and make sure that the colours, sizes and any other details are clear to the viewer. Potential customers need to see what you are selling otherwise they will get confused and go elsewhere. The main thing to remember is that you want the potential customer to see your work, whether it is a product or service, and think, 'Yes, I need that.'

BUILDING A BRAND

While you will learn more about your business and be able to tweak things as you go, it is important to have solid foundations when starting out. Don't underestimate the power of a good brand. When putting yourself out there, building an honest brand is key. Know who your ideal client is and then craft a brand that is both true to you and attractive to them. Don't pretend to be something you are not as people will see right through it. While it's important for clients be able to see the face and personality behind the

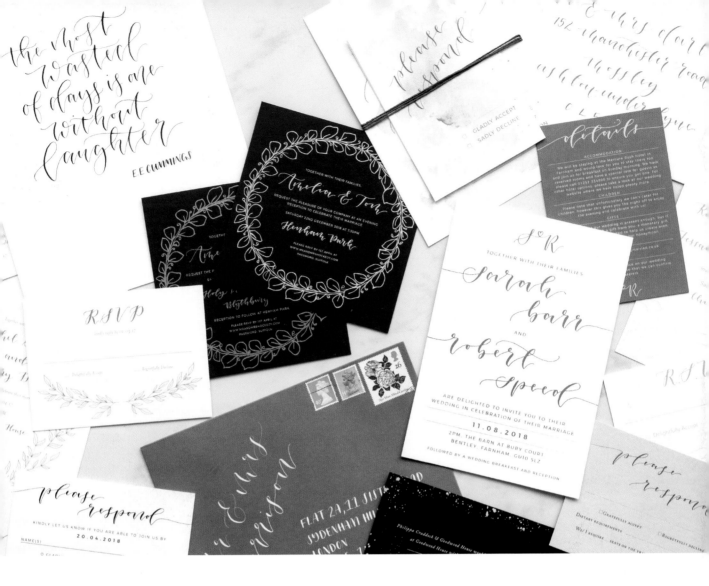

brand, you should be wary of oversharing. For example, clients don't need to see a hundred photos of your home/child/dog, etc. Things don't have to be perfect to start off with. Remember, you can adjust things as you learn more about your brand and what you want it to be. Branding is more than just a logo; it's in the name, the tone of your website, the way you respond to emails, and the photos and posts that you put on social media. Don't rush this part of the process.

PRICING AND VALUE

Pricing is a tricky little devil when starting up and continues to be for a lot of people. My main tip here would be to value your time, skill level and work. If you don't value yourself then no one else will. I have always worked out my pricing based on my ideal hourly rate times, how long I think it will take me, plus materials. To begin with when you are doing something new it might be a bit hit-and-miss with the

timings as you haven't done it before, but the more you do, the easier it will be to work out.

COMMUNITY

Community rather than competition is very important to me, and something I'd strongly recommend to anyone looking to establish an online business. Build up a tribe of like-minded people because they will help you out, give you insanely good advice, listen to you, make you feel less lonely and dish out pep talks when you need them. I have a community of wedding suppliers, without whom I am certain I would not be where I am today, and a community of stationers who are superstars and, collectively, I am pretty sure they know everything. I am lucky enough to have met calligraphers who, instead of calling competitors, I call friends and share jobs and advice with. These people are the first to celebrate my wins alongside me and pick me up after my failures, and quite frankly I would be lost without them.

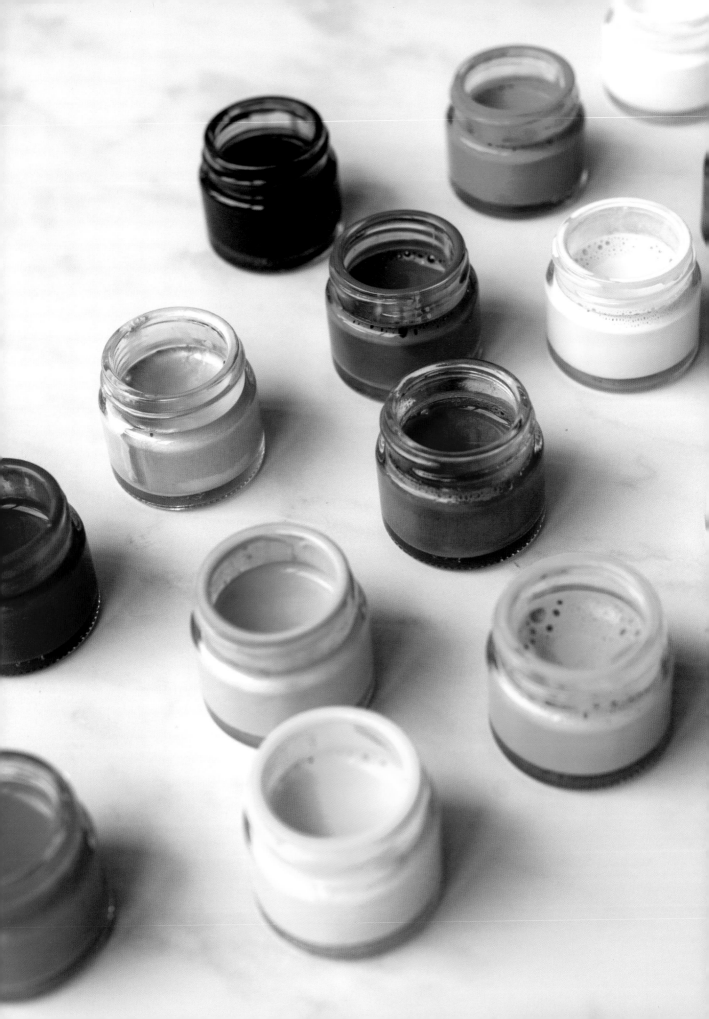

inks & colour

CHAPTER FOUR

An injection of colour to brighten up your lettering.

Take your calligraphy and projects to the next step by using and mixing your own rainbow of calligraphy inks.

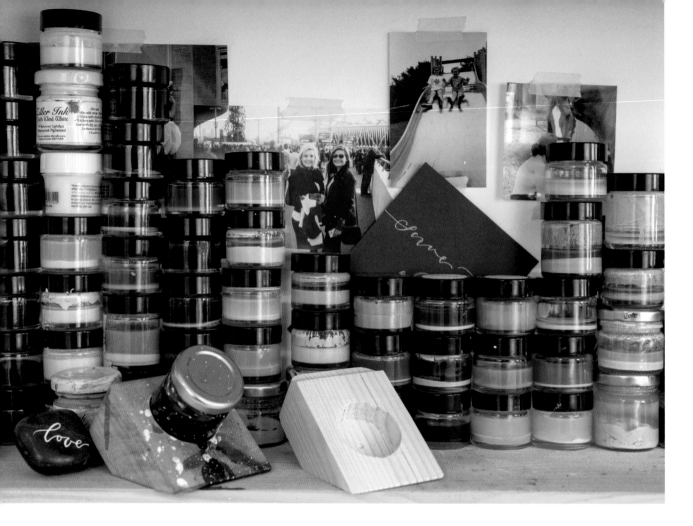

CHOOSING INK

It is best to practise with black ink before experimenting with coloured inks as you might find that the consistency differs and, if you are not confident with your tools, this may throw you slightly off course. Different inks are great for different materials and jobs, but whether you like and use them depends hugely on personal preference. I would not suggest buying a whole range of colours from one brand until you have tried out that brand and made sure that you like it. I have a few (a lot!) of unused inks sitting in drawers, dating back to a time when I got carried away with the rainbow of possibilities, but ended up not liking the ink itself at all.

I tend to make my own inks now if I want to use colour. However, this can be a laborious process so if you are just starting out you might prefer to buy them instead.

BLACK INKS

As we talked about in the Tools chapter (see pages 14–21), my favourite and absolute go-to black ink is Higgins Eternal. This ink is super-black and dries quickly so you don't end up with stacks of paper lying around you waiting to dry. It is not by any means the only black ink on the market, though. Another popular choice is Sumi Ink, which you can buy in a big bottle. This ink has a lovely sheen to it when it dries, which is great for hand-finished pieces, but it takes much longer to dry than Higgins Eternal so is not my first choice for everyday work. Iron Gall Ink is black ink that looks blue when you first write with it but dries to the darkest of blacks.

Black inks to try:

– *Higgins Eternal*
– *Sumi*
– *Iron Gall*

ACRYLIC INKS

My choice for working on paper is always water-based inks as I find them much easier to use than other types. However, sometimes when working on a smooth, shiny surface, for example agate or marble, I instead use acrylic-based inks instead as they are much more permanent and, once dry, will generally not scratch off, although if they are travelling I will seal them to be on the safe side.

Acryllic ink to try:

– *Liquitex*

WATERCOLOUR INKS

Watercolour inks are a great option if you want to do a bit of fancy blending in your lettering and are looking for a slightly textured look, because the consistency will differ as the ink runs out. I love this look when I am handmaking cards and tags. If you use a brush to place the ink on the back of the nib (above the vent) you can keep adding different colours to lend a really gorgeous multi-coloured blend to your lettering. You can also buy concentrated watercolour inks, which are beautifully vibrant and generally work well with a nib.

Ones to try:

– *A simple watercolour palette, or tubes,*
 by Winsor & Newton
– *Dr. Ph. Martin's Concentrated Water Color*
– *Hydrus Fine Art Watercolor*

METALLICS

So much of my work is done in metallic – what is there not to love about a gorgeous sparkly bit of calligraphy? It adds a little bit of luxury to whatever handmade piece you are doing and gives a lovely touch to gift wrapping, cards, tags etc. There are lots of metallic inks on the market and everyone tends to have a favourite. The nib you use and the pressure you naturally apply to the pen have an effect on the consistency of ink you will find most useable.

Metallic inks to try:

– *C Roberson and Co Liquid Metal Ink*
– *Dr. Ph. Martin's Iridescent Copperplate Gold*
– *Finetec*

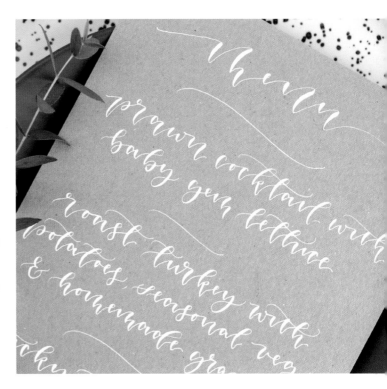

White ink gives a lovely effect on coloured papers

WHITE INKS

Sometimes there is nothing more beautiful than white ink on a dark background. The key to getting white to look fantastic is to use really opaque ink.

Again, there are a few different ones to choose from, but my favourite is Dr. Ph. Martin's Bleedproof White. You have to add a little water to it to thin it out, but it is lovely and opaque when it dries. It's best to use a small mixing pot and add a little water at a time to achieve the right consistency. If you add too much, remove the lid and leave the pot in a warm place so some water can evaporate.

Ones to try:

– *Dr. Ph. Martin's Bleedproof White*
– *Ziller Ink North Wind White*

MIXING YOUR OWN INKS

I tend to mix all of my inks from scratch now. It gives me complete control over the consistency and colour, and also allows me to match to particular colours that clients want. I started off mixing metallic inks because I could never find any gold ink that I loved both the tone and the consistency of, but I soon realised that I could mix whatever colours I wanted. I now have a whole shelf in my studio designated to all my lovely hand-mixed inks, and I sell them online to those who don't want to make them themselves.

Mixing your own inks is pretty simple, but testing the colour and consistency can be quite time-consuming. However, as with everything, the more you practise, the better you become. I can now get the ink consistency more or less spot on with only one test and measuring by eye.

YOU WILL NEED

- Small jars

- Gouache

- Water

- Syringe

- Paintbrush (flat is preferable)

- Test paper

- Gum Arabic

- Kitchen paper

- Pearl Ex Powdered Pigment

- Measuring spoons

HOW TO MIX INK

1. *Take a clean jar or container.* I tend to mix in 100ml jars and then decant into smaller 15ml jars, which is what I use day to day. I buy my jars in bulk but you can use mini jam jars or any kind of jar that is deep enough to dip your nib in.

2. *Add your gouache to the jar.* Start off with just a squeeze if you are using a small pot. To give you an idea of ratios, I use a whole 14ml tube for 100ml of ink. For your first couple of attempts I would suggest sticking to a basic colour that you don't have to mix with another. When you are feeling a bit more confident with your mixing skills, then you can start mixing two or three colours together for a completely unique tone. Remember, when you are lightening a colour by mixing it with white, add the white first and then a touch of the colour. You will be surprised at how much white you need to add in order to dilute bright colours.

3. *Add a touch of water with a syringe and mix thoroughly with a paintbrush.* If you are mixing a variety of colours together, then test the colour on a piece of paper. This will give you a good idea of the tone and you can judge what else you might need to add. Remember, the ink will dry slightly darker. Therefore, if you are colour matching, wait until it dries for a true representation of the colour.

4. *Add more water* until you achieve a consistency similar to double (heavy) cream, add a drop of Gum Arabic and mix well.

5. *Test the ink with your nib* – I tend to do a couple of lines of drills to really test that the ink consistency works for me and the nib I am using. Let your work dry fully before you count on the colour being right.

6. *Add a little more water if needed*, and test again.

TIP Add water a little at a time. You can always add more, but taking it away is trickier! If you do find that you have added too much water then leave the lid off for a while and some will evaporate.

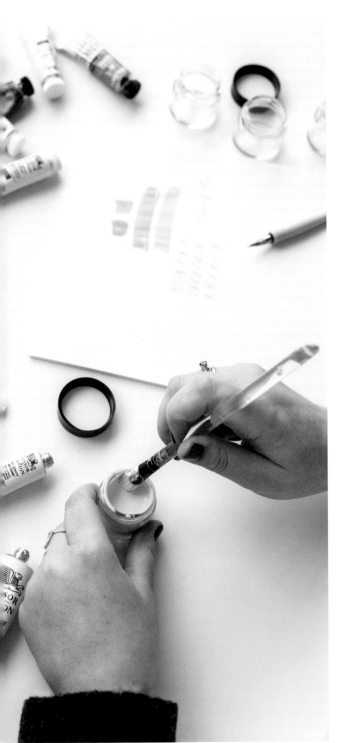

METALLICS

Mixing metallics is pretty much the same as flat colours but you might use some metallic pigment to really make it sparkle. My favourites are Pearl Ex powders, you can get them in a wide range of colours and they give the best shine. You can either mix them on their own or add gouache as well. If you are using them on their own you will need a touch more Gum Arabic.

TROUBLESHOOTING WITH DIFFERENT INKS

Sometimes you might find that you are working with a paper and ink that together cause bleeding. If this is for a specific project or job you may not be able to change them, but there are a few things you can do to potentially stop the bleeding:

Try Changing Inks

Inks react differently to different papers due to variations in consistency and water content. Try a variety to see if one works better.

Add Gum Arabic

You can add a little drop of Gum Arabic to bind the ink and make it a bit thicker. Add a little at a time and test so you don't overdo it.

Mix Up Your Own Ink

If all else fails, then gouache might be the answer. Using the steps that we talked about mix your own gouache-based ink and try that. Remember to add Gum Arabic.

projects

In this section, you'll find lots of exciting projects to build
your confidence with. Remember, practice makes perfect,
so don't be disheartened if something doesn't
look perfect right away – it rarely does!

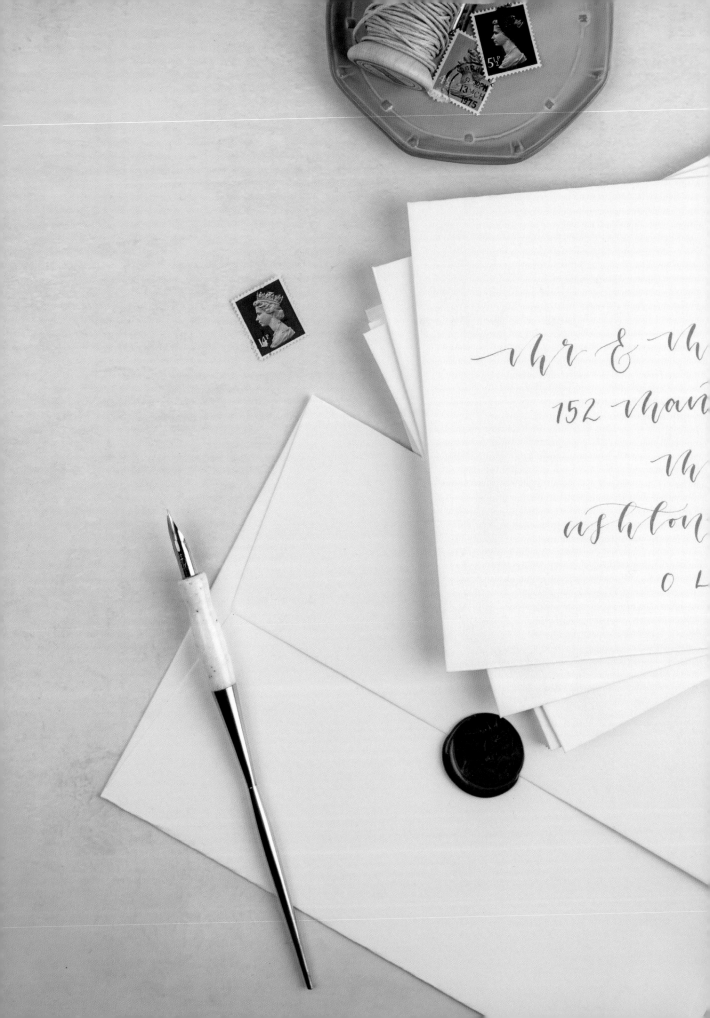

CHAPTER ONE

Put pen to paper and get creative with your calligraphy skills.

From greetings cards to celebration banners, you'll find plenty of projects to fill your home with, and to make for others.

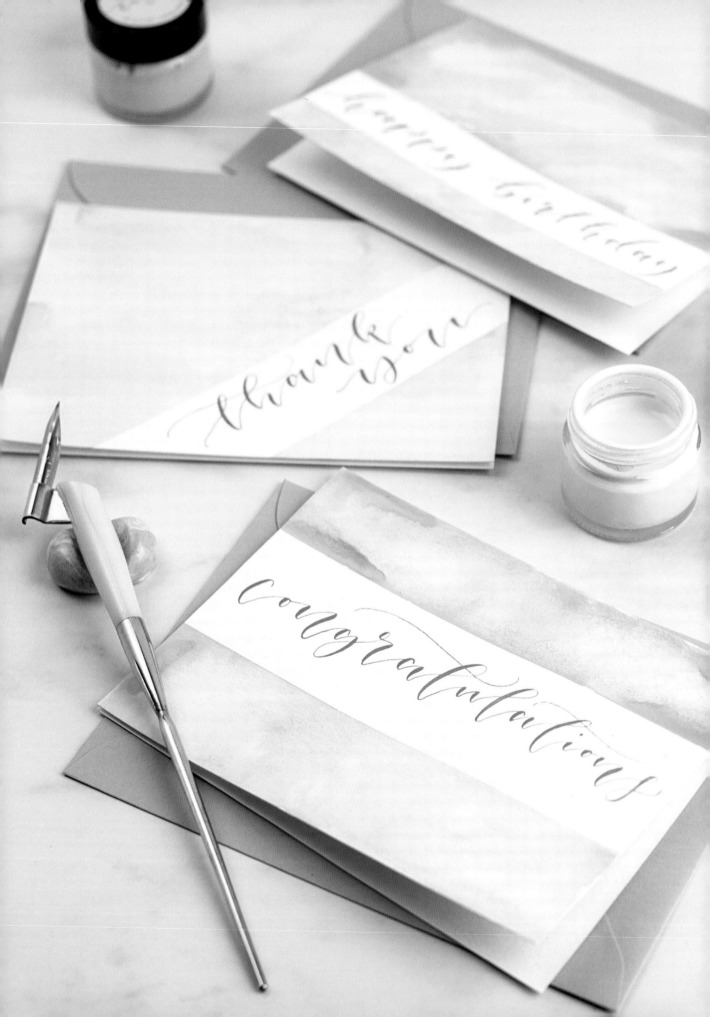

creative cards

WATERCOLOUR
GREETINGS CARDS

There is nothing nicer than receiving a handmade card. Whether it is for a special occasion or just a little note to say thanks, giving someone something that you have put your creativity and time into making is undoubtedly a gesture full of kindness and love.

Greetings cards are really easy to make and even the simplest of designs can have the biggest of impacts. For this project, I used the simple, but effective, style of watercolours in cotton candy colours – perfect for a child's birthday or maybe a baby shower. These cards can easily be adapted to suit whatever event you are creating them for. I always like to make cards in batches then keep the extras for the next event I have coming up.

YOU WILL NEED

– *Plain cards and envelopes*

– *Washi or low-tack tape*

– *Scrap paper*

– *Three or more watercolours or inks*

– *Writing ink*

– *Pen and nib*

– *Pencil (optional)*

– *Drying rack*

– *Heavy book or two*

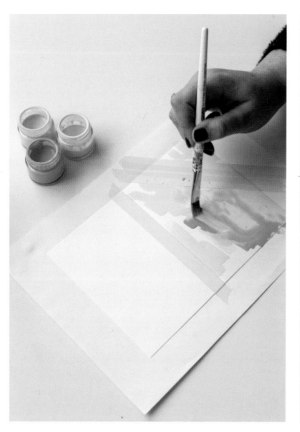

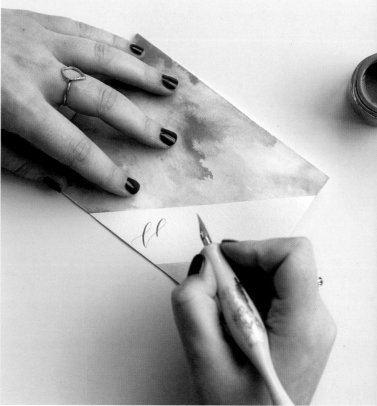

BEFORE YOU START

Make sure you have researched which paper will work for this project by doing a test run first. I always use the same paper, Colorplan by GF Smith, for cards and have a big box full of pre-folded plain cards stashed away to save time.

I use a minimum of 270gsm, which is thick enough to take lots of water and ink without warping too badly. Once you find a paper stock that you like it's worth making a note of it or stocking up so that you have it for the next time you want to do a project.

PROCESS

1. *Take your card and mark out your spacing,* sticking washi or low-tack tape on the parts you want to leave untouched by the watercolour. Mark out where you want the lettering to go. Place a scrap piece of paper underneath and tape it to that. This will help keep your card flat as you paint. Also place a piece over the crease to stop your paint going over on to the back of the card. Washi tape is great for things like this as it is low tack so won't tear the card when you pull it off.

2. *Choose what colours you are going to use for the pattern.* I chose three pastels that worked well together for mine. You want to use colours that complement each other in a pattern. Blob them one by one all over the card – be messy and overlap the colours so they run together! The beauty of watercolours happens when they all run together naturally, making unique patterns. Place your card flat to dry.

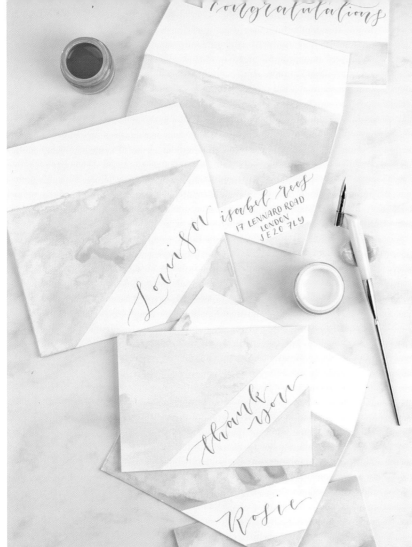

When it comes to greetings cards, there are so many ways to improve on the basic design. You can change your artwork, add metallic touches by flicking metallic ink, or paint over the dried artwork.

The loveliest way to complement the cards created in this project, however, is to create a matching watercolour envelope – just make sure you leave a large enough gap in which to write the recipient's address.

3. Once dry, peel the washi tape off to reveal a very neat unpainted section of the card. Choose a shade of ink that complements the ones you used for the watercolours. I chose grey, but you could also choose a colour that you used as part of your mix. Write out your message. If you are unsure of spacing then do it very lightly in pencil first, rather than in writing ink. You can always go back and erase it after the ink is dry. Place your card in the drying rack to dry.

4. Looking bendy? Once your card is dry, place it under a heavy book or two to flatten it – ideally leave it overnight, or at least for a couple of hours.

5. Get writing. Once the card is flat, open it up and write a message to your loved one. You can either write with your pointed pen or, if you are feeling the pressure of writing a long message, a normal pen – the front design is what counts!

GET THE MOST FROM YOUR NEW SKILLS

These watercolour creations are great for many occasions, from birthdays and anniversaries to graduations and baby showers.

You can also adapt them to use as invitations. Write on the front of them 'you're invited', then pop the details inside for a simple yet beautiful invitation to your next party.

Keeping a supply of cards and envelopes also means you can send a little note of love whenever the feeling takes you.

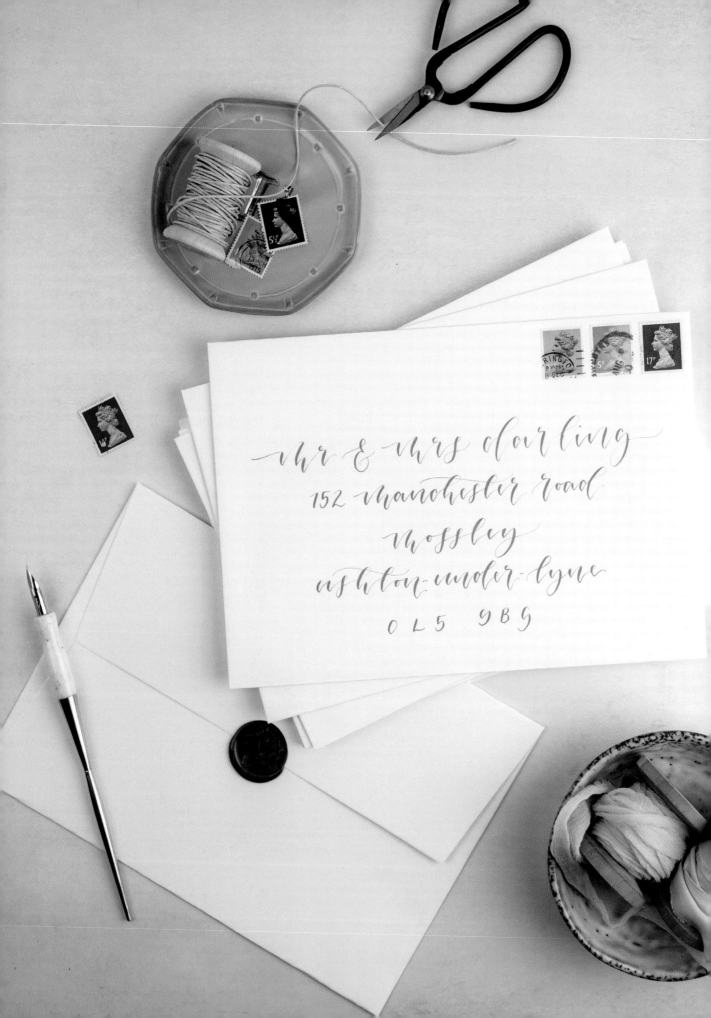

mr & mrs darling
152 manchester road
mossley
ashton-under-lyne
OL5 9BG

fancy envelopes

ENVELOPE ADDRESSING

Fancy envelopes add a special touch to any kind of mail. Whether you are sending out wedding invitations, Christmas cards or just writing a letter to a friend, a beautifully composed envelope is guaranteed to make the recipient smile.

It is always worth thinking about what kind of event the envelopes will be used for. For example, neon ink and glittery stars might not be suitable for a formal dinner. You should also always take into account the scenario in which the envelopes will be seen or received before planning your design.

In terms of address etiquette, there are a few different ways in which you can use people's names. For an informal event, using first names may be absolutely fine, but for something more formal it is important to make sure that you know the full names of any recipients and always use any titles accordingly.

YOU WILL NEED

- *Good-quality plain envelopes*
- *Pencil*
- *Ruler*
- *Laser level*
- *Eraser*
- *Chalk pencil if working on dark paper*
- *Pen and nib*
- *Ink*
- *Drying rack*
- *Stamps and wax seals*

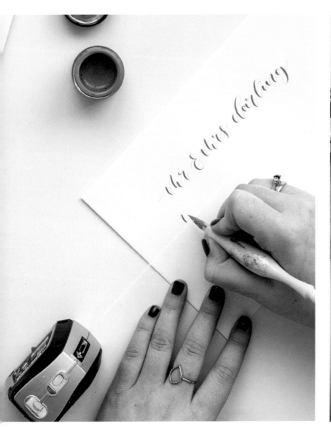

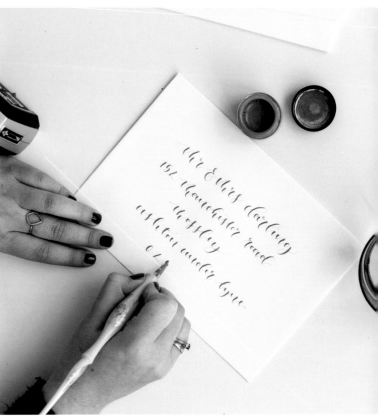

BEFORE YOU START

Laying out an envelope is pretty simple but it can take some practice to get the spacing and centering correct. There are a few tools that can help you, but patience and planning is key. If you jump in at the deep end with no prep, you may end up wasting quite a few envelopes.

If you are doing a big batch of fancy envelopes then make sure you have extra supplies in case of any mistakes or mishaps (I make sure I keep to hand 20 per cent extra of all the materials I will use).

PROCESS

1. *Check your alignment.* If you are centering your addresses, which is a standard layout for envelope design, then type the address on your computer first in a word processing program and centre it. This will show you the relation of the words to each other and give you an idea of where you need to start each line.

2. *Mark out your spacing.* Work out the spacing between each line and make a mark with a pencil along both of the short edges of the envelope. I usually leave 1.5cm between lines. You can also draw a faint pencil line down the centre of the envelope to mark where the middle of your lines should fall.

3. *Get on the level.* Now take your laser level – not a tool that is specifically used for calligraphy but one that will save you hours of line drawing and erasing – and place the line so that it touches the marks you have made on either side of the envelope for an instant straight line to write your address on.

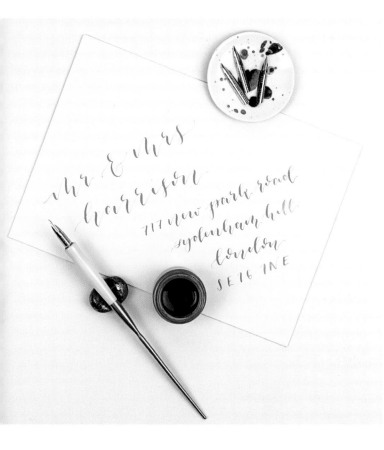

UP YOUR GAME

Now you have learned the basics of a central-aligned envelope layout we can mix that up with some wild angles and embellishments. Start playing around with some fun angles for your addresses. You could treat the names and address as two different sets of text, bringing one in at an angle and the other on a straight line. But always remember that you need the address to be legible. You can also use a huge variety of different colours for your envelopes and inks. I personally love white ink on dark greys and navy – I think it just looks so simple and classy. You can also add little sketches or shapes to your envelope to make it into a one-of-a-kind piece of art.

*4. **Clean up.*** Once you have finished writing the addresses, go back and, making sure that the ink is dry, erase any pencil marks you have made.

*5. **Add some finishing touches.*** Once you have your envelopes all addressed and ready to go, you can add some fancy stamps and wax seals. We will discuss making bespoke wax seals later on (see pages 118–21) but you can also buy ready-made wax stamps with gorgeous illustrations or single letters on. Choose a wax colour that complements your envelope for the perfect finishing. You can also buy different-coloured postage stamps to complement your design – just make sure that they are for the correct postage value!

GET THE MOST FROM YOUR NEW SKILLS

In a world of social media, texting and email communication, the ancient art of letter writing and posted correspondence doesn't seem so important – but nevertheless a personalised message that has been handwritten with care, in a fancy envelope, is something that can be treasured forever.

There are so many things that you can put in a fancy envelope – wedding or party invitations, thank-you cards, birthday cards, love letters, thinking-of-you letters, time capsules, letters to your baby....

motivational quotes

WALL ART

One of the first things that I started making when I first learned calligraphy was wall art gifts for friends, usually their favourite song lyrics or, for weddings, their first dance track.

It is a great way to practise and makes a lovely handmade gift, and there is also no digitising involved, which is great if you aren't very confident with that process.

YOU WILL NEED

– Pencil

– Scrap paper

– Lightbox

– Card stock

– Pen and nib

– Ink

– Frame

PROCESS

1. **Plan, plan, plan.** Use a pencil to write out your quote. Take notice of natural breaks in lines and letters that will sit well together. For example, you want to avoid having a letter with a descender directly above a letter with an ascender because the two will clash and bump or you will end up having too much space either side above letters that don't have ascenders. Try multiple ways of laying out the quote and then see which is most pleasing to the eye. Take into account the balance of the overall design.

2. **Once you have decided on a layout,** write it in pencil to size on a scrap piece of paper.

3. **Get tracing.** Using a lightbox, place your chosen card stock over the pencil lettering on scrap paper and trace it using your pen and ink. Go slowly to avoid making mistakes. When finished, leave to dry.

4. **Frame it.** Pop your finished artwork in an attractive frame and you now have your own original piece of wall art.

if you live to be a hundred,
i want to live to be a hundred
minus one day so i never
have to live without you

A. A. MILNE

This project offers you a basic skill
set for making original, hand-drawn
pieces of art. You can use these
skills to decorate your home or make
gifts for others.

*If you are a proficient artist then you
could even create wreaths or other
patterns around the calligraphy, for a
stunning finishing touch.*

happy banners

CELEBRATION BANNERS

Whether it's for child, a teenager or an adult, a Happy Banner is a simple and effective way to brighten up any birthday bash. These versatile, fun banners can also be used for all sorts of other celebrations and parties.

It is essential to know the theme, colour scheme and amount of space you have available when planning as this will influence the size of your banner. For this project, I used an emerald-green medium Uni POSCA Marker (my favourite paint pen for paper work) and A6-sized white card. If you have a lot of space available then you can work with larger sheets of card.

YOU WILL NEED

– A6 sheets of card

– Pencil and steel ruler

– Scalpel and cutting mat

– Eraser

– Uni POSCA Marker

– Hole punch

– String (I use Baker's Twine)

Hang up banners EVERYWHERE. I guarantee you can make these banners fit in with any decor. Not only can you use them for any celebration – birthdays, baby showers, retirement parties, engagement parties and many more – you can also make them a permanent fixture in your home (or someone else's).

How about a newborn baby's name for their bedroom? Or, why not string up a favourite motivational quote in your home office. The possibilities are endless … so go wild!

PROCESS

1. On each sheet of A6 card, mark the middle point and draw a line vertically. Then measure 4cm (or more if your paper is larger) up from the bottom edge and make a dot.

2. Cut out the shape. Using a steel ruler and scalpel (making sure to lean on a cutting mat), make a cut from each bottom corner up to the dot you made in the last step, cutting out a triangle shape from the bottom of each piece of card. Erase the pencil marks.

3. Line up one piece of card per letter. I like to have them lined up when I write as it helps me to visualise where the letters should go so they look consistent and smooth along the banner. Now, using your paint pen, write out your letters.

4. Mark the holes on each sheet of card (on the back). I made mine 2cm in from the edge on each side. You want two holes on each piece of card. Using a hole punch (single if you have one), punch holes in each piece of card and then erase any pencil marks.

5. Measure the space you have to hang your banner. Cut a length of string or twine that is about a quarter longer than that space as you want it to hang down a bit and have enough left to tie it at the ends. It is always better to have too much than too little! Thread the cards on to the string by threading from back to front on the first hole and then front to back on the second hole, and so on. The friction between the cards and the string will keep them in place, so space them out how you like, then hang up your banner!

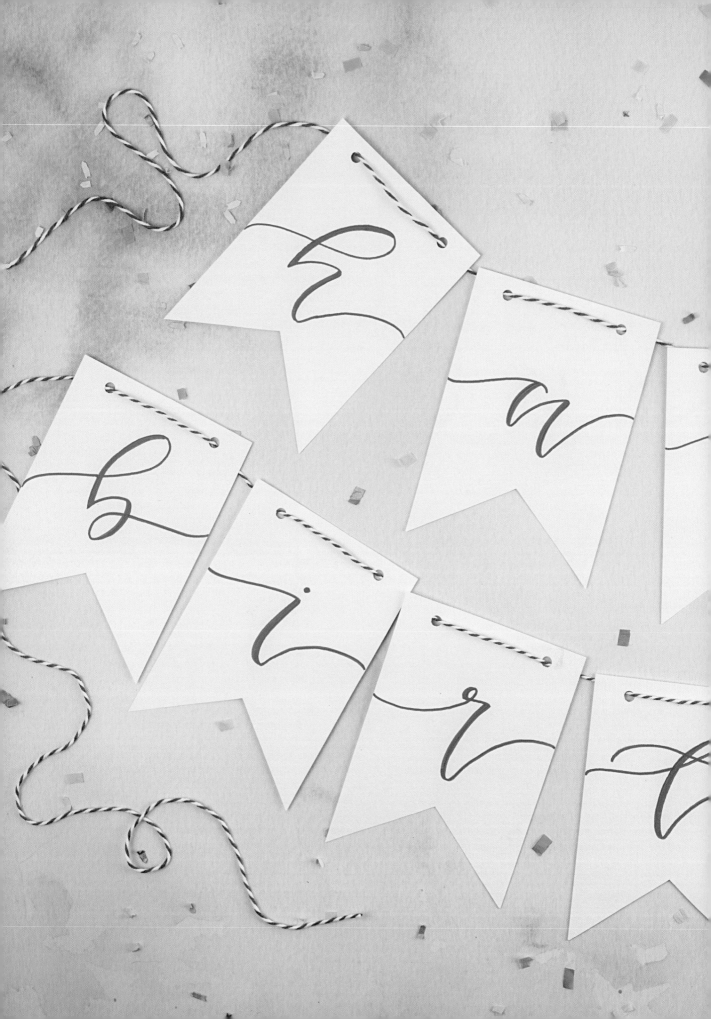

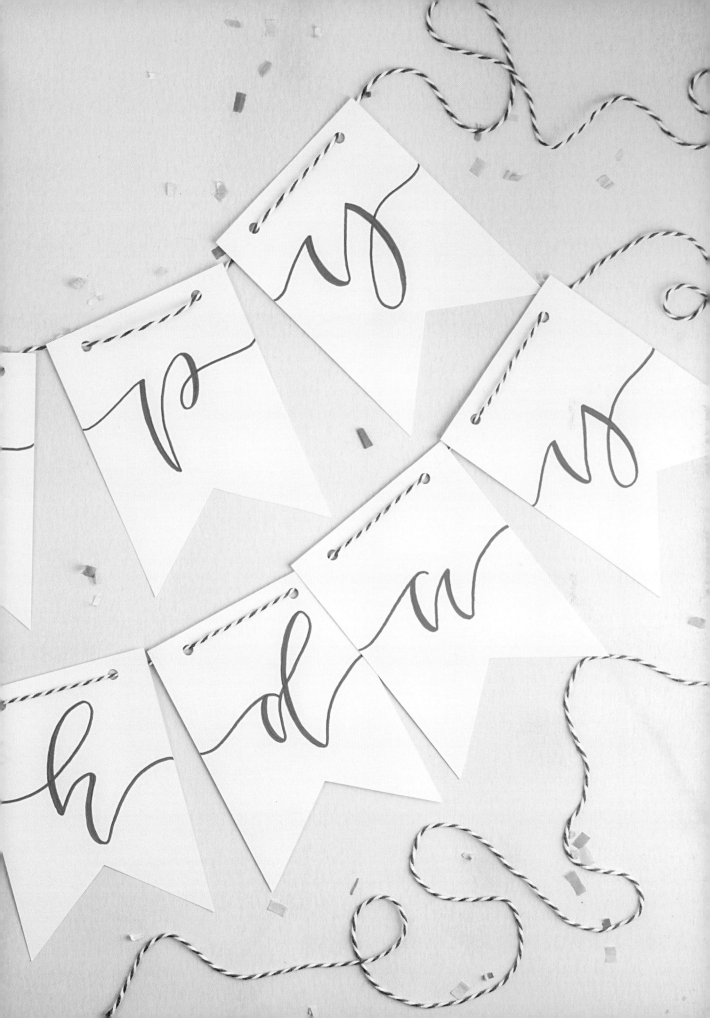

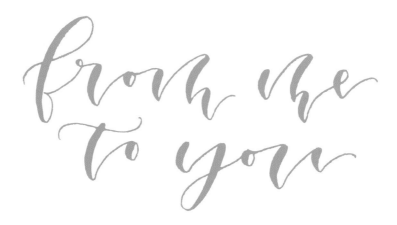

GIFT TAGS

A calligraphy gift tag adds a lovely personalised finishing touch to a beautifully wrapped present. It's also a great way to practise and show off your new calligraphy skills.

You can either buy ready-made tags or you can purchase a gift tag punch to make your own from flat pieces of card. Remember to test the card stock you are using before making the tags so you aren't left disappointed with bleeding ink or an unsuitable surface. Think about what size of tag to use; I like oversized tags like the ones pictured, but if the present you are attaching it to is very small then this won't work, so use a more delicate-sized tag.

YOU WILL NEED

– *Plain gift tags (or card stock and gift tag punch)*

– *Pencil and eraser*

– *Pen, nib and ink*

– *Drying rack*

– *Twine or ribbon*

PROCESS

1. ***Pick a colour tag and ink.*** They should complement not only each other, but also the giftwrap or bag you will be putting them on.

2. ***Making your own tags?*** Punch a hole a few centimetres in for attaching twine or ribbon.

3. ***If you need to, mark it out.*** If you aren't confident about doing the calligraphy freehand, then very lightly mark out the lettering in pencil or mark out lines on the tag to keep your writing straight and neat. This is a particularly good idea if you are writing a long message.

4. ***Get writing.*** Using the ink you have chosen, write out the message on the tag.

5. ***Leave it to dry in a drying rack.*** Once it has dried, erase any pencil marks left behind.

6. ***Bring it all together.*** Thread your twine or ribbon through the hole, then attach to your present for one beautiful, ready-to-go, hand-lettered tag.

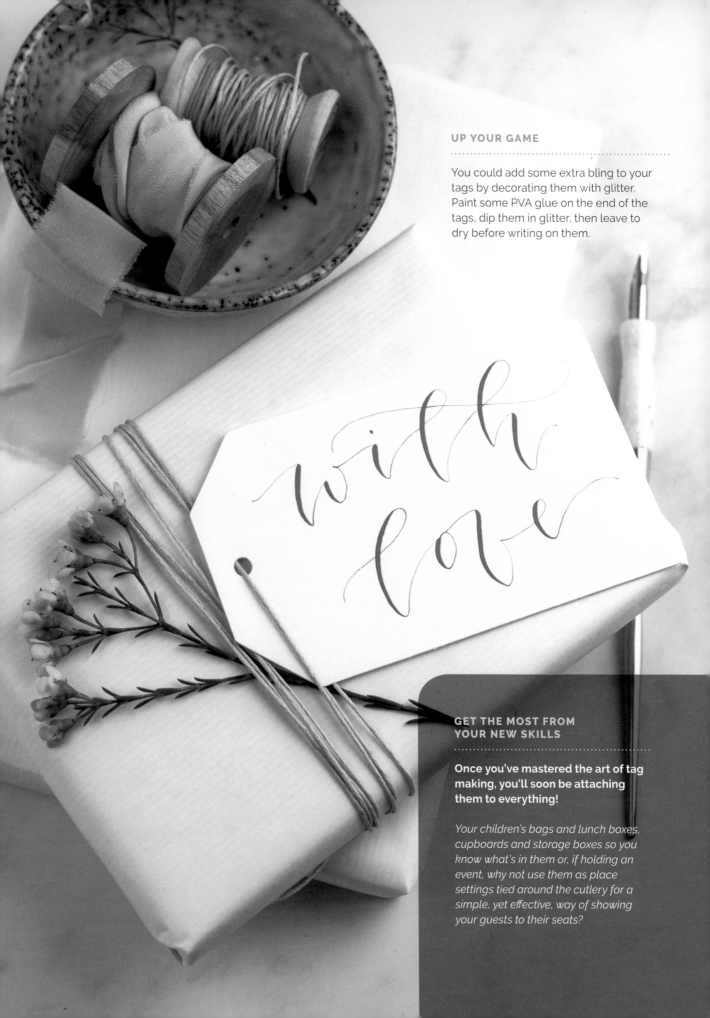

UP YOUR GAME

You could add some extra bling to your tags by decorating them with glitter. Paint some PVA glue on the end of the tags, dip them in glitter, then leave to dry before writing on them.

GET THE MOST FROM YOUR NEW SKILLS

Once you've mastered the art of tag making, you'll soon be attaching them to everything!

Your children's bags and lunch boxes, cupboards and storage boxes so you know what's in them or, if holding an event, why not use them as place settings tied around the cutlery for a simple, yet effective, way of showing your guests to their seats?

Sweet things

SPARKLY STAR
CUPCAKE TOPPERS

Who doesn't love a cupcake, especially one with a personalised topper? This project is great for jazzing up cupcakes for a birthday party or get-together.

The toppers in this project are for cupcakes, but you could upsize and make them for bigger cakes if you prefer. You might need to use longer sticks, though, and add one to each side of the banner. You can make your toppers any shape you like, but choose something that suits the event you are holding.

YOU WILL NEED

– A4 sheet of card

– Pencil and eraser

– Ruler (optional)

– Scissors

– Pen, nib and ink

– Drying rack

– Magic Tape

– Toothpicks

– Glitter paper

– Star shape paper cutter

PROCESS

1. *Using a pencil, draw the shape you want your topper to be on the card.* I made mine a wiggly shape so drew it freehand, but if you want straight edges then use a ruler. Make sure the topper is large enough to fit your lettering on. If you are unsure, it's a good idea to draw a practice one beforehand and test the size with your calligraphy.

2. *Cut out the shape using scissors,* then erase any pencil marks left behind.

3. *Write your chosen lettering on to the topper.*

4. *Let it dry on a drying rack.* Once the ink is dry, turn it over and use some Magic Tape to stick each one on to a toothpick.

5. *Throw some shapes.* Take the glitter paper and shape cutter and cut out some glittery stars to stick on to your topper and add a sparkle to your cakes.

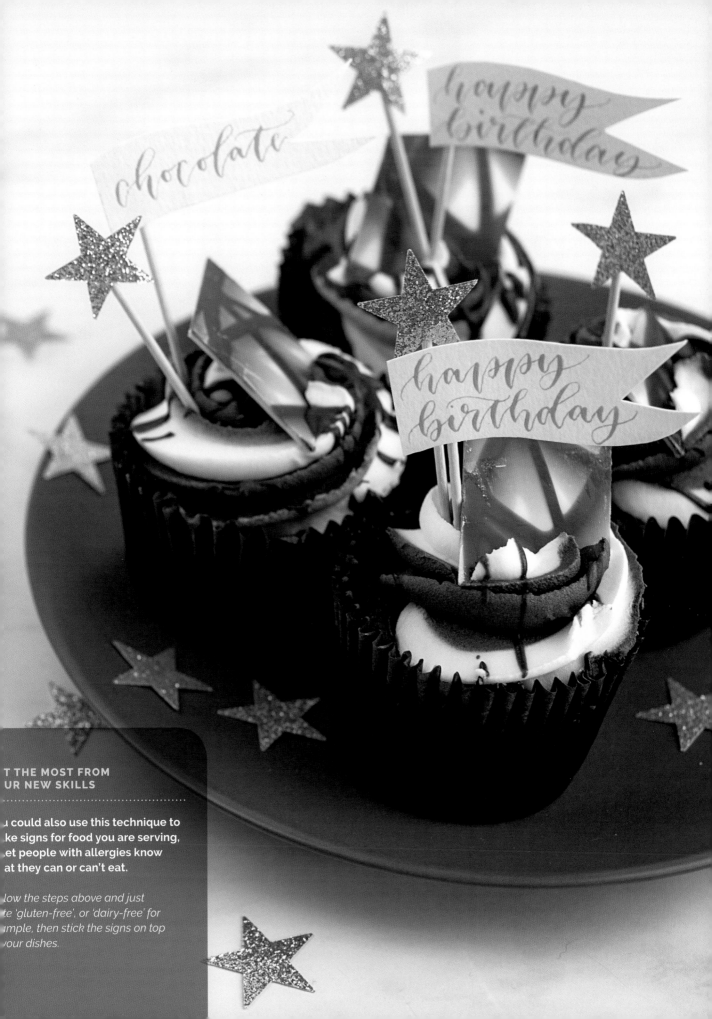

u could also use this technique to
ke signs for food you are serving,
.et people with allergies know
at they can or can't eat.

low the steps above and just
te 'gluten-free', or 'dairy-free' for
mple, then stick the signs on top
our dishes.

plan it out

MENU PLANNER

There is nothing better than a bit of calm organisation to make day-to-day life flow a little easier, and one of the best ways I've found to keep on top of a busy schedule is to have a meal plan in place. With this simple project you can create a gorgeous meal planner for your kitchen, which will help you map out all your family meals for the week ahead, saving you time each day.

There are two options with this project: you can either draw it by hand or create a digital version, if you feel comfortable with the digitising process. I made a digital planner so that I can print a new one off each week and start afresh.

YOU WILL NEED

- Scrap paper

- Pencil

- Computer (if digitising)

- Ruler and fineliner (if creating by hand)

- Pen holder, nib and ink

- A4 paper or card

PROCESS

1. **Map it out.** Decide how many boxes you want – everyone is different. I work from home so I take lunches into account as well. Take a piece of scrap paper and work out the grid.

2. **If you are digitising your design, get on to the computer.** I created mine in InDesign and used coloured boxes, with varying strengths of colour as spaces to write the meals in. If using tinted backgrounds, be sure to print off and check that you can write over them and that they aren't too dark.

3. **If creating your planner by hand, use a ruler and fineliner to draw your grid or boxes.** Use your original layout plan to work out the measurements and spacing.

4. **Calligraphy time.** Whether you have hand-drawn your design or used a computer, it's time to add some calligraphy. I did all my lettering in calligraphy, but you could use a mixture of calligraphy and fonts for your headings. If you are digitising, then do some calligraphy in black ink to scan and then drop into your design. If your design is hand drawn you could choose a bright-coloured ink to jazz it up.

5. **Printing time.** For digital designs, it is now time to print them off. I print out a few copies at a time and pop them on to a clipboard, which I keep in my kitchen – easy to pick up and fill in then move on to the next page at the end of the week!

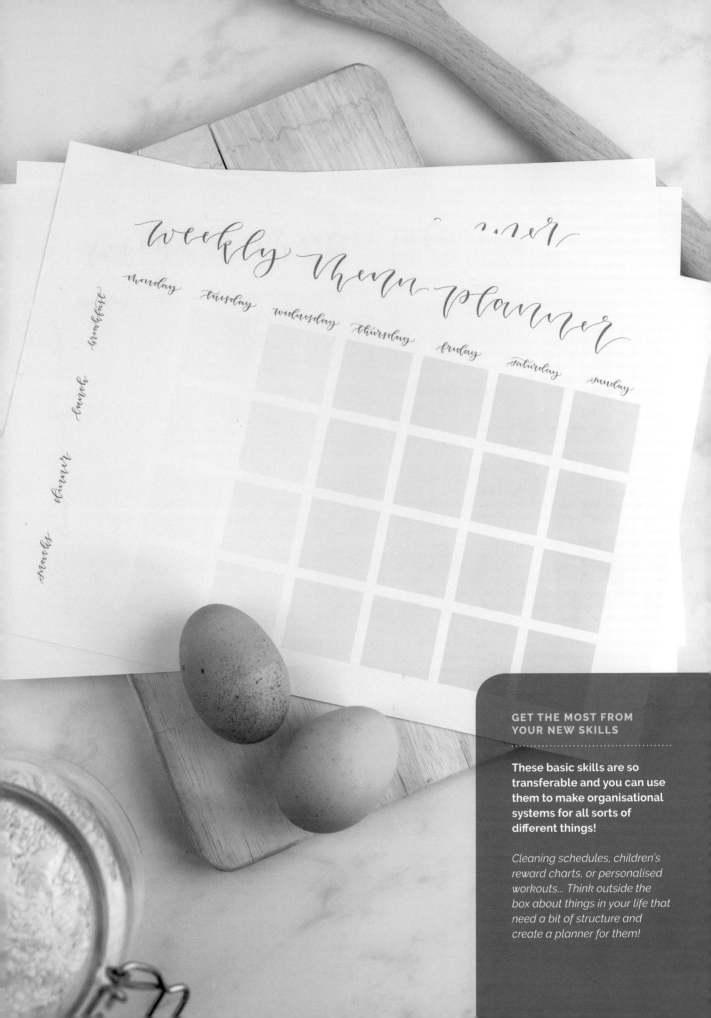

weekly menu planner

monday
tuesday
wednesday
thursday
friday
saturday
sunday

breakfast
lunch
dinner
snacks

GET THE MOST FROM YOUR NEW SKILLS

These basic skills are so transferable and you can use them to make organisational systems for all sorts of different things!

Cleaning schedules, children's reward charts, or personalised workouts... Think outside the box about things in your life that need a bit of structure and create a planner for them!

NEON NOTECARDS

These fancy little notecards are great to have to hand for adding to parcels or sending as thank-you cards. You could also write your name on them and keep them on your desk to use as personal correspondence cards.

Decide on a colour scheme that suits your personality. I wanted bold neons so I chose acrylic, but you don't have to use acrylic paints. If you want a softer look, opt for a watercolour mix. Washi tape or a low-tack tape is best for this project; anything with too much tack will pull up the fibres of the paper when you remove it.

YOU WILL NEED

- *A6 pieces of white card*
- *Washi tape or low-tack tape*
- *Scrap paper*
- *Neon acrylic paint*
- *Pen holder and nib*
- *Drying rack*

PROCESS

1. Decide on the pattern that you want to paint on to your cards and place the washi tape so that it creates a straight line. Use the washi tape to stick the card to a piece of scrap paper if you are planning on going up to the edges, so that your card doesn't move around.

2. Paint the space that you want to be coloured. Go over the washi tape so that you create a nice clean straight line. I painted three layers of acrylic paint, leaving each layer to dry for 10–15 minutes, because I wanted the finish to be really opaque. If you are using a softer watercolour instead then you will only need one layer.

3. Once the paint has dried, carefully peel off the washi tape. You should now have a nice, clean line of paint.

4. Using your pen holder and nib, add whatever wording you want to the cards. I like to write a short, sweet message such as, 'From the desk of Lauren' or 'Thank you, love Lauren', in calligraphy on a few notecards and keep them to hand so I can quickly scribble a message with a ballpoint pen whenever I need to. Leave to dry on a drying rack.

from lauren

lots of love !

just a note to say

lots of love

Fluorescent Pink
538
D·LER · ROWNEY
system 3 original
CRYLIC

GET THE MOST FROM YOUR NEW SKILLS

You could use the painting technique described here for many other projects, including greetings cards and tags, or even for making a small run of business cards.

Simply print the information on some plain white card then jazz it up with some neon paint.

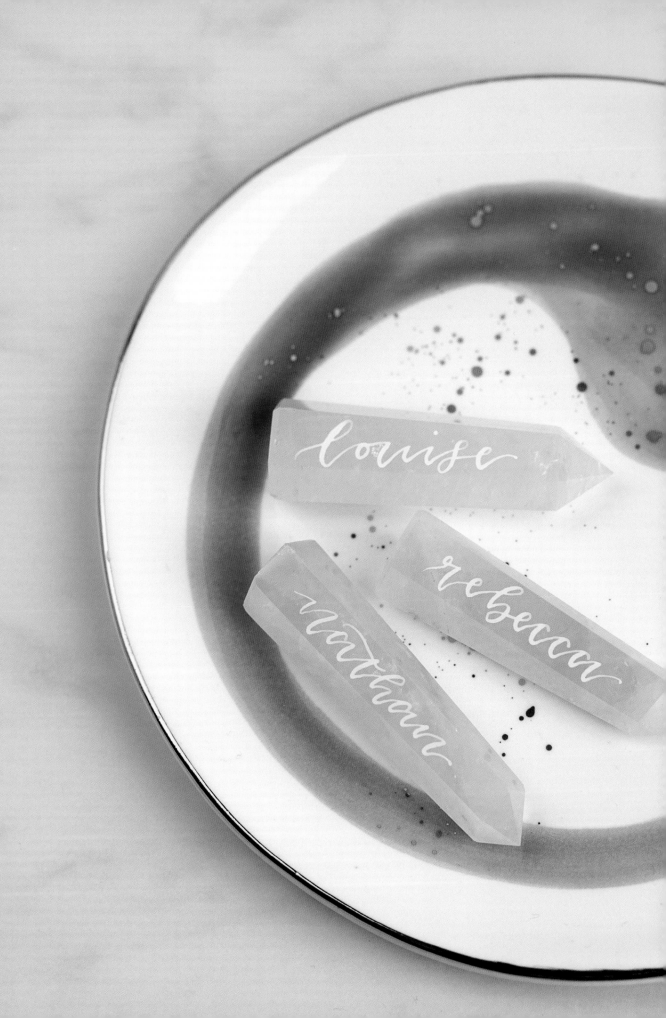

other materials

Be prepared to start writing on everything!

Modern calligraphy is not only for paper. Once you feel confident
with your letterforms, you can use a variety of tools and materials to create
lovely items such as wooden signs or hand-decorated gemstones.

The Menu

woodfired pizzas

MARGHERITA · HAM + PINEAPPLE ·
CAPRICCIOSA · DOUBLE CHEESE · VEGE

burgers

DOUBLE CHEESE · BACON + AVO
MUSHROOM · CHICKEN · VEGETABLE

salads

GREEK · CAESAR · SALMON
BACON + AVO · TUNA NICOISE

drinks

working with wood

WOODEN BAR MENU

Wooden signage is incredibly versatile and relatively easy to do if you have the right tools. It is key to plan beforehand, as with any large-scale work, so that you know the amount of spacing you will need. There are many different stains you can use on wood to make it suitable for use in any environment.

I generally use plywood for all my wooden signage, which I buy from local DIY stores. You can cut it to size yourself, or a lot of large stores will do this for you, so check out your local one to see if they offer this service. Make sure the surface of your wood is smooth, otherwise it won't stain well and will quickly wear down your pens.

YOU WILL NEED

– *Smooth MDF or plywood, cut to size*

– *Sponge*

– *Wood stain*

– *Scrap paper*

– *Pencil*

– *Ruler*

– *Magic Tape*

– *Uni POSCA Marker (medium)*

– *Chalk (optional)*

– *Magic sponge or eraser*

– *Outdoor wood varnish and brush (optional)*

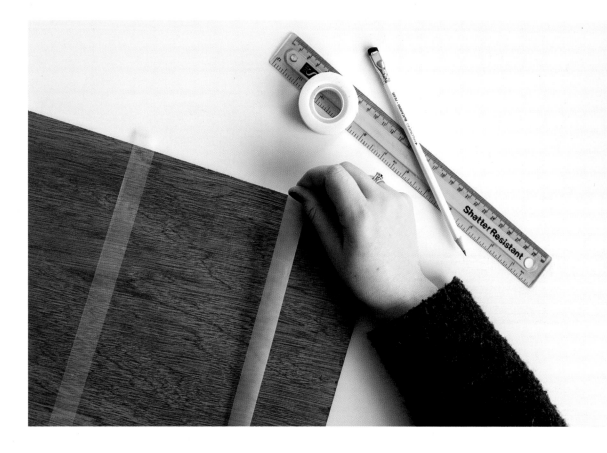

PROCESS

1. ***Prep your wood for staining*** by dusting it off and making sure that there is no debris on it. Then, using a sponge, carefully apply the stain, following the instructions on your stain pot. You don't want streaks, so build it up slowly. Leave to dry thoroughly.

2. ***Meanwhile, plan out the lettering*** on a piece of scrap paper to make sure everything fits on and to work out your measurements.

3. ***Once the stain is dry*** (leave it overnight if possible), use Magic Tape to mark out your lines and spacing on the wood. This low-tack tape won't pull off any of the stain when you remove it, and is great for marking out lines when you are working upright.

4. ***Pick up your Uni POSCA Marker,*** it's time to get lettering. You can use either faux calligraphy or monoline lettering. If you need to, you can write your lettering in chalk first to check your spacing. If you go really lightly, you can wipe off any bits that you don't write over in pen with a magic sponge or an eraser.

5. ***Once your lettering is dry,*** your board is ready. If you plan to use your sign outside, weatherproof it first with a good coat of varnish.

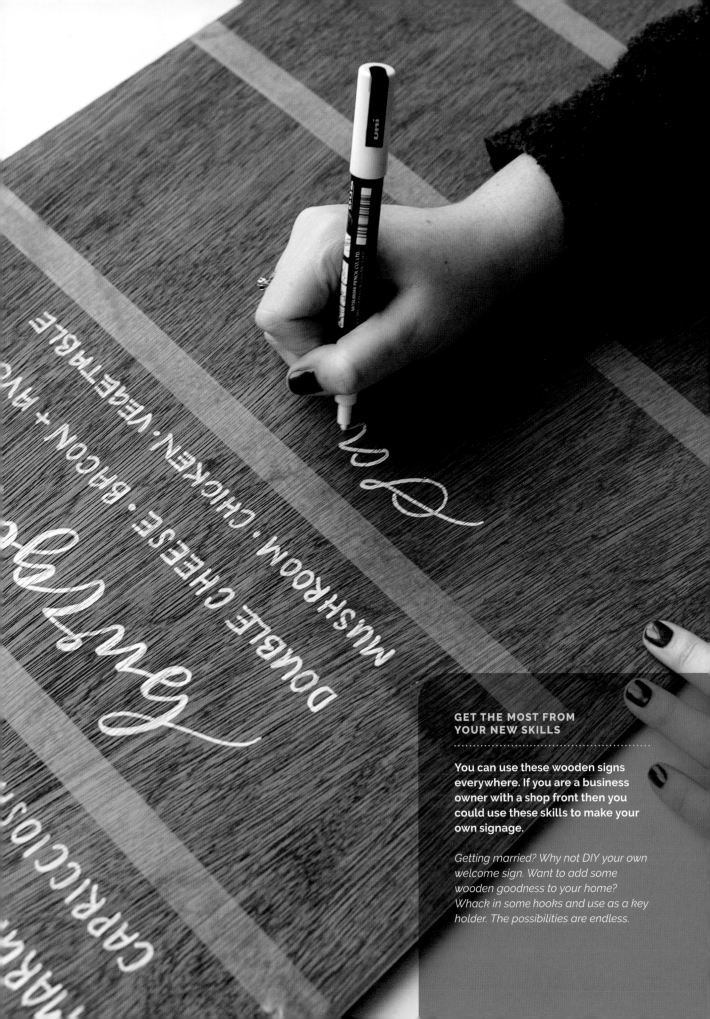

GET THE MOST FROM YOUR NEW SKILLS

You can use these wooden signs everywhere. If you are a business owner with a shop front then you could use these skills to make your own signage.

Getting married? Why not DIY your own welcome sign. Want to add some wooden goodness to your home? Whack in some hooks and use as a key holder. The possibilities are endless.

TABLETOP
CHALKBOARD MENUS

A tabletop menu will add a touch of flair to a dinner party, not only giving you a chance to show off your new skills, but also letting the guests know what deliciousness to expect from the meal. Most chalkboards are double-sided, allowing you to write on both sides so everyone around the table can see what you are serving.

You can buy small chalkboards online, or you can make your own using some MDF and chalkboard paint. If you don't have a stand, you could use a decorative plate display stand to hold the board up. Take into consideration the size of your table and party when choosing the size of your board. A4 is a standard board size and should be easy to source.

YOU WILL NEED

– Pencil

– Scrap paper

– Ruler

– A4 chalkboard and stand

– Magic Tape

– Chalk or chalk pencil

– White Uni POSCA Marker

– Damp cloth or magic sponge

PROCESS

1. *Using a pencil, write out your menu on scrap paper to check the spacing.* I like to centrally align signage but if you are worried about getting everything wonky then you can align it to the left.

2. *Mark out any straight lines on the chalkboard using Magic Tape.* Then, using a piece of chalk or a chalk pencil, very lightly mark out your lettering. This way you can see if you have got your spacing correct and make any amendments without messing up the 'real thing'.

3. *Using your chalk marker, go over your chalk marks and do your lettering!* Don't worry if you mess up. You can wipe off mistakes with a damp cloth or magic sponge and write it out again.

4. *Play around with some extra touches.* If you are a confident illustrator, or just fancy a little play, then add some embellishments to the design with florals and wreaths. You could even illustrate the dishes you'll be serving.

5. *Leave to dry for a few minutes* (paint pens tend to dry very quickly), remove any Magic Tape, then pop the menu on a stand and position it ready for all your guests to read and admire.

Menu

Sundried tomato
bruschetta

Sea bass with
new potatoes &
spring greens

Raspberry Cheesecake

GET THE MOST FROM
YOUR NEW SKILLS

**Chalkboards are great to
hang in the kitchen for lists
and meal plans.**

*Create some fancy lettering
at the top and keep a stick of
chalk handy for scribbling
down the week's plans!*

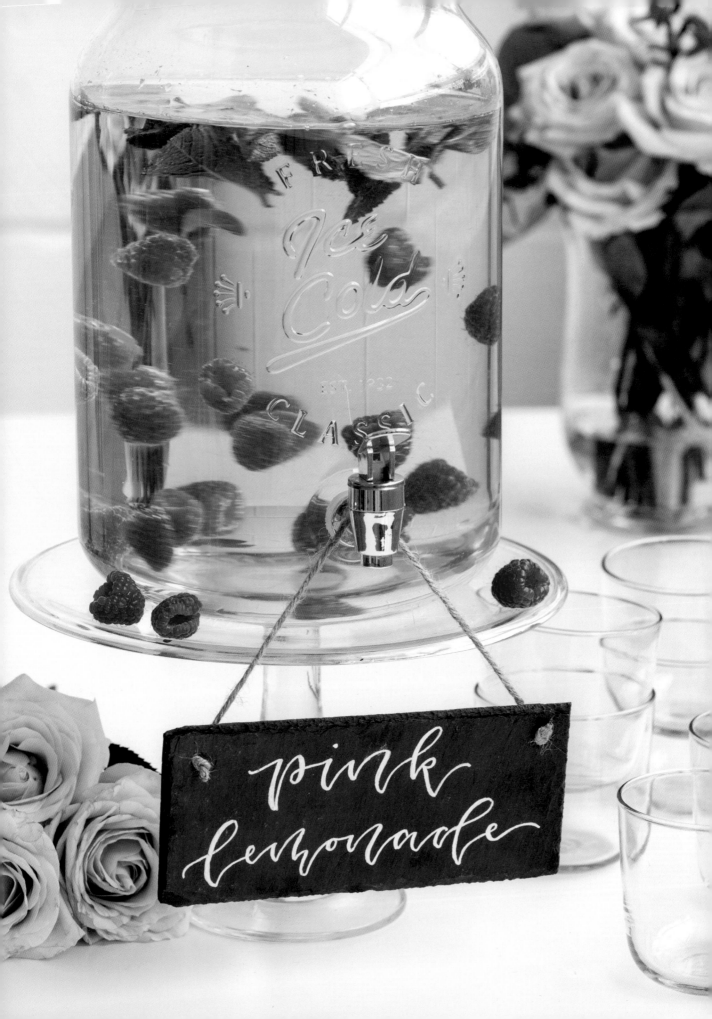

cheers

SLATE DRINKS DISPENSER SIGNS

If you're planning on hosting the garden party of the year, then a drink dispenser is a must. And what better way to let your guests know what delicious drinks you are serving than to hang up a rustic slate sign?

I bought ready-made slate signs from Etsy, but you could find a piece of slate, drill in some holes and thread through some rope. My signs are 18 x 8cm, which is a great size for drinks dispensers, but you can use whatever size is most readily available.

YOU WILL NEED

– *Hanging slate sign*

– *Damp cloth or kitchen paper*

– *Chalk or chalk pencil*

– *Uni POSCA Marker*

PROCESS

1. *Give your slate a good clean using a damp cloth or kitchen paper.* Make sure you clean off all the dust and loose pieces of slate before you begin writing, otherwise your pen will get gunked up, preventing a smooth, even flow of ink.

2. *Using your chalk or chalk pencil*, lightly sketch out what you want the sign to say. You can use a wet cloth to wipe off any mistakes.

3. *When you are happy with the layout and spacing, go over it with a Uni POSCA Marker.* Thicken up your downstrokes, to make it look like faux calligraphy.

GET THE MOST FROM YOUR NEW SKILLS

These slate signs also make lovely door hangings!

You can write kids' names on them or perhaps hang a sign on the bathroom door for guests.

Say cheese

SLATE CHEESEBOARD

This is the ultimate in fancy entertaining, so quick and simple to make, it would be a shame not to. Along with handwritten place names, this cheeseboard could take pride of place on your dinner table and be the perfect excuse for entertaining and showing off your new calligraphy skills.

I bought my slate online and chose an 18 x 32cm piece, but depending on how many types of cheese you plan to serve, you might need a different size. I would advise laying out the cheeses with space between each and then measuring how much space they take up.

The beauty of slate is that it is very hard-wearing. Using a sponge, give it a good scrub with some washing-up liquid and clean the lettering off, and it is ready to use it again!

YOU WILL NEED

– *Piece of slate*

– *Chalk or chalk pencil*

– *Uni POSCA Marker*

– *Damp cloth or kitchen paper*

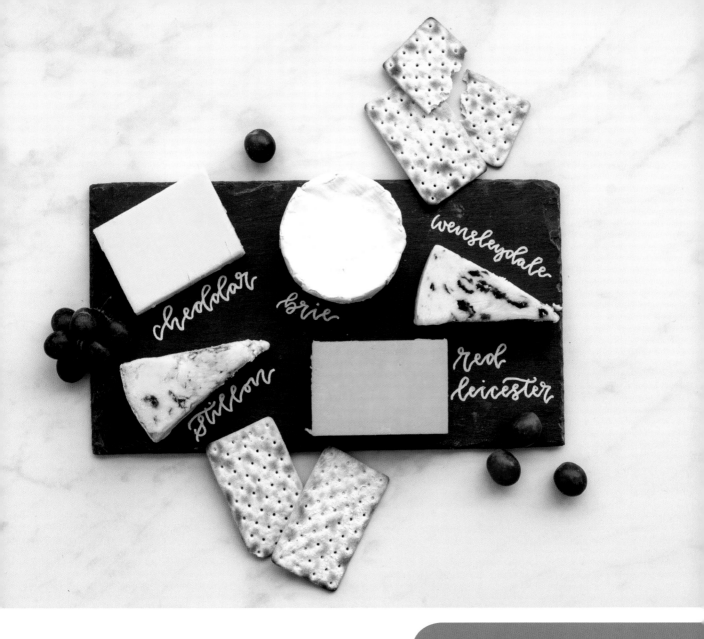

PROCESS

..

1. Lay out the cheeses on the slate, making sure there is a large enough space between each for your lettering.

2. Use chalk or a chalk pencil to plan your lettering to fit around the cheeses. I like to write in a curve for round cheeses, and so forth. Think of ways to make your layout look fun and interesting.

3. Remove the cheeses and get lettering! Using a Uni POSCA Marker, write on the slate slowly as there will be some dips in the surface and you don't want your pen to get caught and flick ink.

4. Let the ink dry, then pop all your cheeses in the correct places. Now you just need to prepare for the oncoming awe that your guests will show when you lay the cheeseboard on the table.

GET THE MOST FROM YOUR NEW SKILLS

..

You can use this slate board idea for serving many other types of food.

Perhaps for canapés, a tapas course or a dessert fondue. Just change the size of slate accordingly and get lettering.

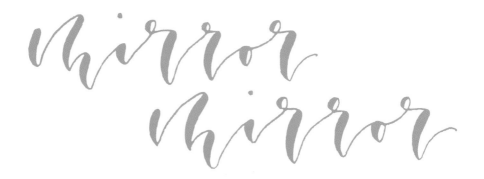

MIRROR LETTERING

Lettering on mirrors has become such a trend for weddings and events over the past few years that I cannot begin to count how many I have written on. My first professional job for Oh Wonder was a mirror table plan. While they can look a bit tricky, the key is in planning and marking everything out before starting. The lettering itself is relatively simple and the best thing is you can wipe off any mistakes and start again, should you need to.

The secret weapon for mirror lettering is Magic Tape. Rather than using guidelines that you then have to remove, you can use this tape to mark out any measurements and lines that you need for the design and pop the tape on. The Magic Tape that I use is 2cm wide so I take that into account when planning and make all gaps 2cm. Preparation is all for big-scale work like this, especially if you are making something such as a table plan with lots of lettering on. I always measure the surface first and then do a sketch plan with measurements on for each line etc. There is nothing worse than getting halfway through a piece and then realising you are going to run out of space. If you are proficient with a design program, such as InDesign, then you can plan it out on there; if not, then pencil and paper is fine.

YOU WILL NEED

– *Mirror*

– *Window cleaner and cloth*

– *Pencil and paper*

– *Ruler*

– *Magic Tape*

– *Uni POSCA Marker*

– *Duster*

PROCESS

1. *Make sure your mirror is super clean and free of dust.* Any dust and debris will get caught up in your pen and cause the ink to drag and be patchy.

2. *Once you have done the spacing out and know your measurements, use Magic Tape to mark it all out on the mirror.* Do this in one step, rather than as you go, as it is extra reassurance that everything will fit.

3. *Start writing.* Don't be nervous, water-based paint pens, such as POSCAs, will rub off if you make a mistake. Go slowly, and try not to get handprints on the mirror – if I find that I am leaning on the mirror too much and making prints, I lean the base of my hand on a duster to stop this.

4. *Once dry, slowly remove the Magic Tape, then your mirror is ready.* You can go over it very lightly with a duster to remove any dirty spots, but don't rub too hard or the lettering will come off.

GET THE MOST FROM YOUR NEW SKILLS

Mirror lettering doesn't have to be limited to event signage.

You can practise at home and leave little notes of encouragement on the mirrors around your house, or even use one for a dinner party menu.

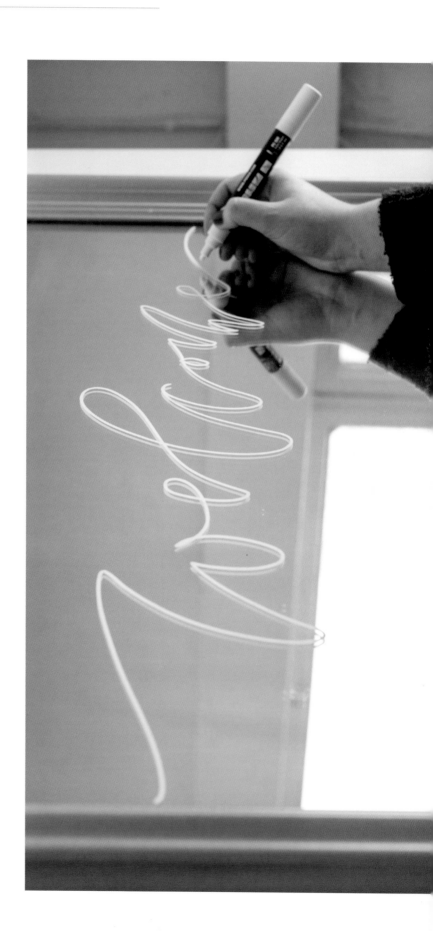

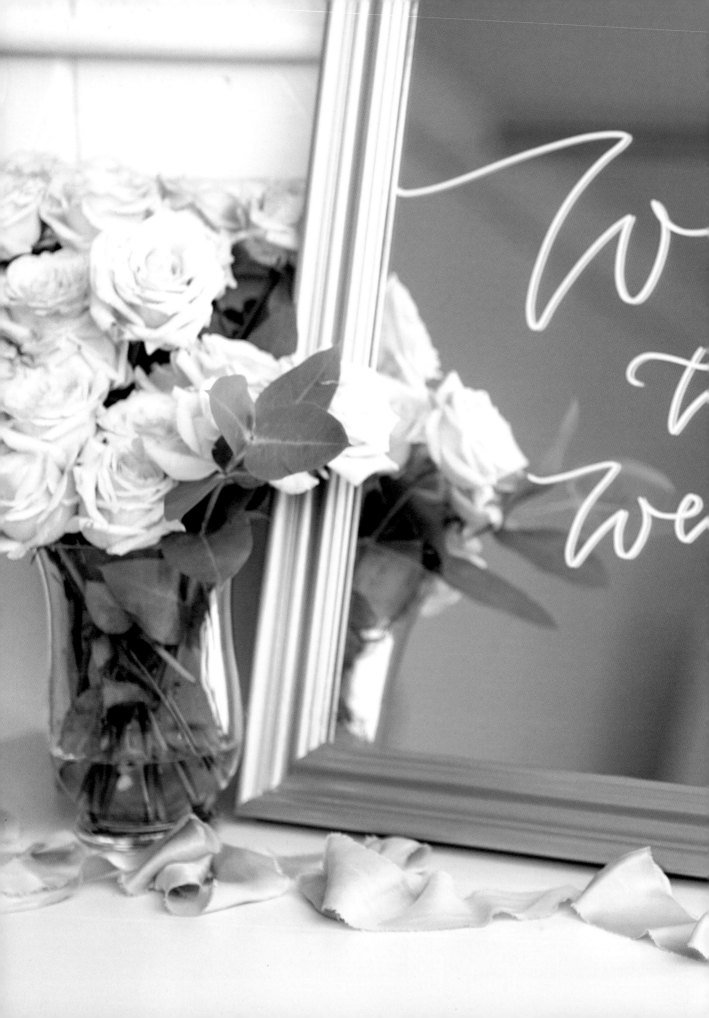

welcome

to our

wedding

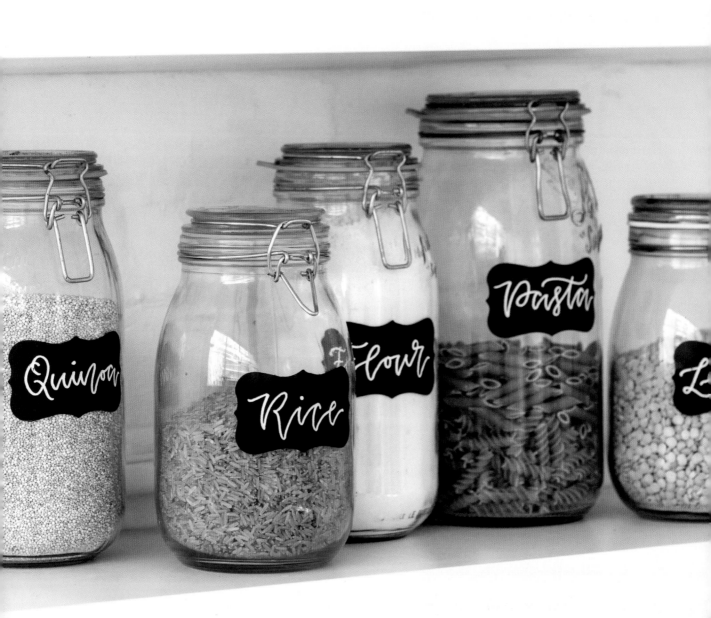

get organised

FOOD CONTAINER LABELS

This project could not be easier, and these gorgeous labels will add style and function to your kitchen. You'll love them so much that you'll soon be adding labels to anything and everything around the house.

I bought my chalkboard labels online, and chose black as they stand out the best on glass jars, but you can shop around to see what you prefer. My pack even came with chalk pens, but I used Uni POSCA Markers. Check your labels are the right size for your jars and big enough to fit your lettering on to. You can buy glass food jars from many suppliers; Ikea and supermarkets are my go-to stores for them.

YOU WILL NEED

– Chalkboard labels

– White Uni POSCA Marker

– Chalk or soapstone pencil (optional)

– Jars of delicious food

PROCESS

1. **Choose which labels you are going to use** – my pack came with lots of different shapes.

2. **Using your chalk marker, write out the name of whatever you are filling the jar with.** If you are feeling a bit unsure, mark it out lightly first using chalk or a soapstone pencil. Leave the lettering to dry for a few minutes.

3. **Stick the finished labels on to your jars** and display all your dried foods with pride.

GET THE MOST FROM YOUR NEW SKILLS

You can stick these stylish labels on almost anything!

Plastic storage boxes, sandwich bags, drawers ... basically anything that will make your life easier.

shiny pretty things

SMALL ITEMS WITH SMOOTH SURFACES

There are a huge variety of different materials that you can write on, and which make great place settings or gifts. You can use a pointed nib for this project, but it will wear down quickly, so it's important to make sure you keep a spare nib on standby. I like to use a nib with medium flexibility – such as the Nikko G or an Esterbrook 358 – and a very, very light hand.

It can take some hunting to find the perfect materials for projects such as this. If you can't find specialist sellers then online sites such as Ebay or Etsy are great sources. You don't want anything too small because it will be impossible to write on. As a general rule, I like pebbles and agate slices to be at least 6cm wide. Crystals can be trickier to find in that size, but try to keep above 4cm or you will really struggle. If you are lucky enough to be picking them in person, then go for the smoothest ones with the flattest sides possible. This will make lettering on them easier; if there are lots of dips in the surface it will be much harder to keep the flow of your calligraphy. In terms of ink, acrylic is the most permanent ink and definitely the best option for metallics. For extra permanency, you can spray with a clear lacquer after the ink has dried.

YOU WILL NEED

– *Chosen materials*

– *Rubbing alcohol*

– *Acrylic ink*

– *Pen holder and nib (medium to flexible*

– *Kitchen paper or cotton pads*

– *Clear lacquer spray*

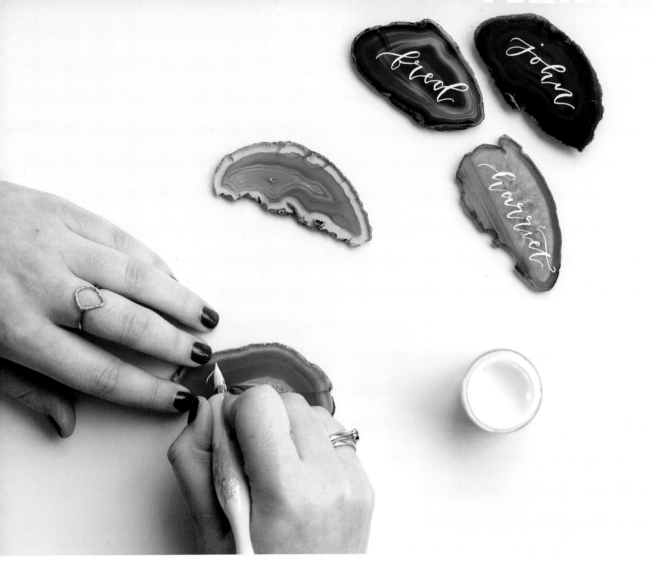

PROCESS

1. My top tip for writing on any shiny surface is to clean it first with rubbing alcohol. This preps the surface so the ink will go on smoothly without beading up. You can also use rubbing alcohol to clean the surface if you make a mistake. Let your items dry for a while after you have cleaned them – it should only take a couple of minutes.

2. Using your chosen ink, start doing your calligraphy. For round objects, such as pebbles, it is easiest to hold them in the palm of your hand and then write. For flat objects, such as agate, place them on the table. When doing your lettering, go really slowly and use the lightest amount of pressure that you can possibly get away with.

3. Keep it flowing. Acrylic inks will build up on your nib and block the flow more quickly than water-based inks. Keep dipping the nib in some water and giving it a wipe to avoid this.

4. Leave for the ink to dry for an hour or so, then spray the surface with clear lacquer if you want your pieces to be super permanent.

5. You're finished! Your decorated items are now ready to adorn any tablescape or be given as the perfect personalised gift.

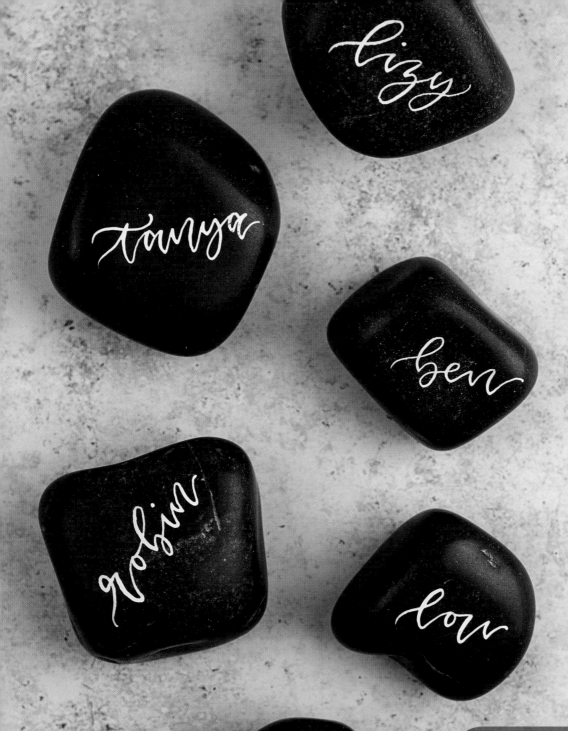

GET THE MOST FROM YOUR NEW SKILLS

······································

Try out your new lettering skills on different surfaces. One of the best things about my job is experimenting with different items that I can do beautiful calligraphy on.

I love it, and present my friends and family with little bespoke pieces all the time.

She Sells Sea Shells

SHELLS

Shells are not too rough but not quite smooth enough to use a nib on, so in comes our saviour, the oil-based paint pen. Extra-fine paint pens are great for navigating surfaces that aren't quite at paintbrush roughness, but that you can't use a nib on either. Nice and forgiving and super smooth to work with, they leave a lovely effect on the surface. The two types of shells that I have based this project on are oyster shells and mussel shells. They are both very popular for weddings and events and make lovely place settings and mementos.

You can find shells on the beach or buy online – there are lots of sites that sell shells for arts and crafts. Make sure they are a good size and have ample space to write on. My favourite paint pen for items like these is the Sakura Pen-touch, extra-fine. The metallics are amazing and are so shiny they look like foil when they dry. The nib is lovely for lettering and lets out lots of ink so you don't get a streaky effect. The ink is oil-based and permanent.

YOU WILL NEED

- *Shells*

- *Scrubbing brush and damp cloth*

- *Paint pen – Sakura Pen-touch, extra-fine*

1. *If you are picking your shells from the beach then you need to make sure they are very clean and dry before writing on them.* Give them a good scrub to get rid of any debris that might be attached to them. If you bought them from a shop they should already be clean, but give them a wipe to get rid of any dirt or dust – you don't want it gunking up your pen.

2. *For smaller shells, place them in the palm of your hand while you write on them.* For larger shells, you can place them on the table. I like to write around the edge curve as the calligraphy always sits really well there and it is smoothest and easiest to write on.

3. *Let them dry.* Oil-based pens dry really quickly, but make sure the ink is completely dry before moving your shells.

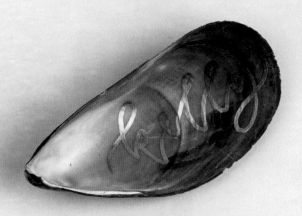

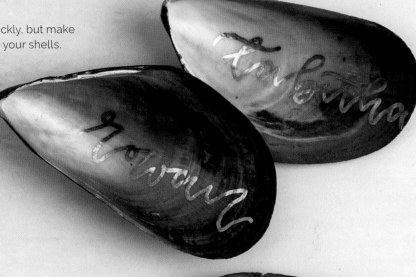

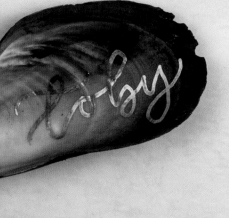

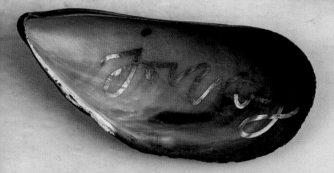

GET THE MOST FROM YOUR NEW SKILLS

Personalised shells not only make lovely place settings, especially for a destination wedding, but they also make great gifts.

You could collect some shells on holiday then add the place and date you were there for a special keepsake.

feeling rough

SMALL OBJECTS WITH TEXTURED SURFACES

The rougher the surface, the trickier it is to write on. You can't use a nib because it will catch and flick ink everywhere, resulting in a very messy bit of calligraphy. The solution is to use a very tiny paintbrush and thicker ink or paint. Natural materials, such as driftwood and sea glass, come under this very rough category (although you can find smoother bits of sea glass). They do look gorgeous, though, if you can put the time into making your lettering work on this surface.

It took me a long time to get used to using a brush, so definitely do some prep work on paper first before moving on to whatever surface you have chosen to use. I have found that the key is to hold the brush very upright and do your lettering slowly and piece by piece. Go lightly to begin with, using a very tiny amount of paint, and then go back and build it up. White ink tends to look best on these surfaces (I used bleedproof white with a minute amount of water added). When choosing materials, make sure they are big enough to write on properly. A lot of stones and pieces of sea glass are really titchy so check what size you are buying first.

YOU WILL NEED

- Scrap paper
- Pencil (optional)
- Chosen materials
- Small paintbrush (2/0 is my go-to)
- White ink (bleedproof white, very slightly diluted)

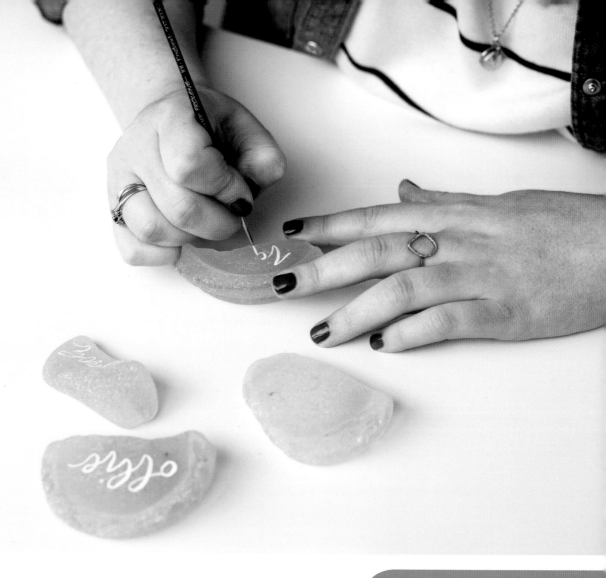

PROCESS

1. Practice makes perfect. If you are not to used lettering with a paintbrush, practise on some scrap paper before you start. It can help to write the letters in pencil first and then go over them in paint or ink. I like to use a size 2/0 paintbrush, but you can go smaller or slightly larger if you prefer.

2. Once you are confident with the paintbrush, you can start applying the lettering to your materials. Go very slowly, and build it up in layers. The first layer should be just the outline of the letters, then on following layers, go back to make them more opaque and build up any thick downstrokes you might need to, as you would for faux calligraphy.

3. Let the ink dry completely. You don't want to smudge anything – unfortunately, it isn't as easy to correct mistakes on rough surfaces as it is for ultra-smooth surfaces. It's always a good idea to keep extras materials to hand in case of any mistakes.

GET THE MOST FROM YOUR NEW SKILLS

Once you have mastered using a paintbrush on rough surfaces, you'll be able to adorn all sorts of interesting materials with your beautiful calligraphy.

Experiment with things that you find out and about, such as slate and rough stones or bits of driftwood.

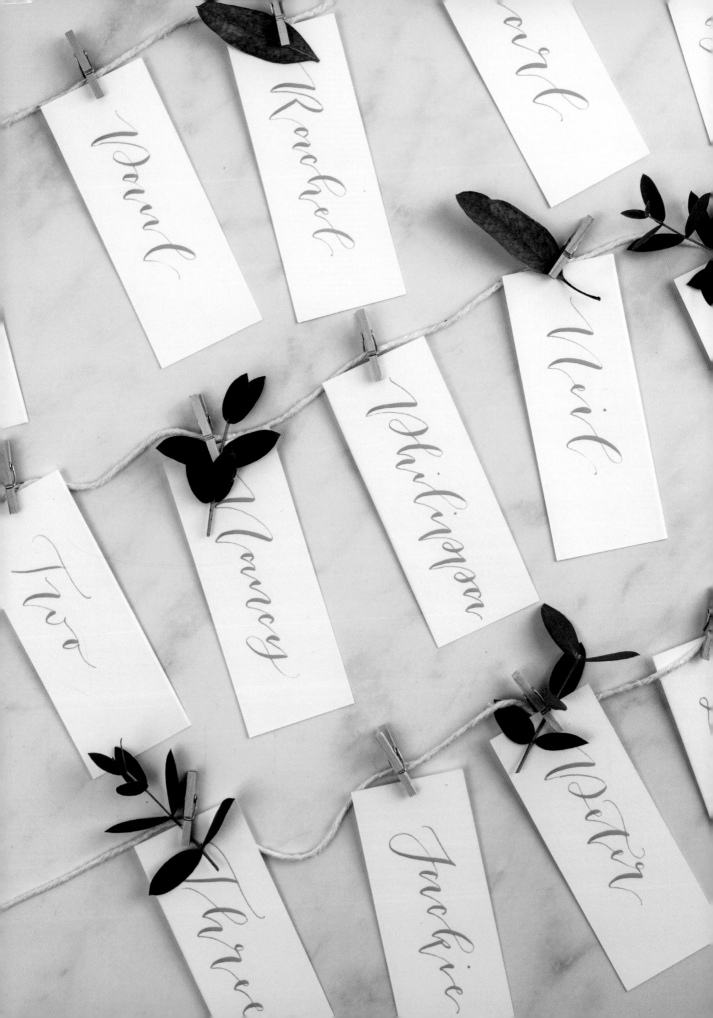

weddings & events

CHAPTER THREE

Getting married or planning a special occasion?

The following pages are full of stunning decorative ideas to enhance
any bride and groom's special day. But don't worry if you're not organizing
a wedding, the projects in this chapter can be adapted to suit any other special
occasion you have in mind – from summer picnics to intimate dinner parties.

you're invited

WEDDING INVITATIONS

Your wedding invitations are arguably one of the most important pieces of paper that you will ever send to your friends and family. In the opening of an envelope, your loved ones are going to get a glimpse of all the ideas, planning and love that is going into your big day and will, hopefully, be filled with a buzz of excitement about what is to come.

If you are feeling confident about the calligraphy skills that you have learned so far and you or someone you know is getting married, then you may be contemplating designing some invitations. This project will help get you started and show you the process that I use.

If you aren't confident with digitising and designing on the computer, there are a number of other ways that you can use your new calligraphy skills. To personalise each invitation, you could add the couples' names, a fancy monogram or the names of the recipients. If you are working with a stationer then make sure you talk to them upfront about your plans so they can allow any space you might need. Don't forget you can also jazz up your invitations by putting them in fancy envelopes.

YOU WILL NEED

– *Paper*

– *Pencil*

– *Layout paper*

– *Eraser*

– *Fineliner (if illustrating)*

– *Lightbox*

– *Pen holder and nib*

– *Black ink*

– *Coloured ink*

– *Computer (if digitising)*

– *Ribbon or twine, vellum wrap, wax seal or a fancy envelope, for bringing the design together*

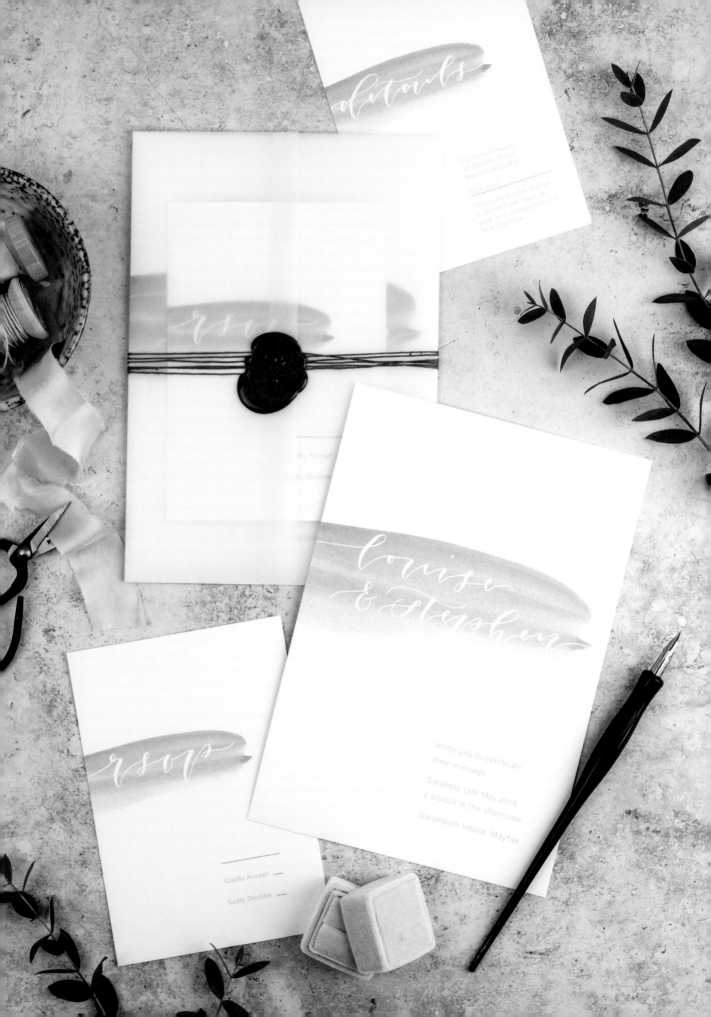

Think about what information
you need to give your guests –
venue, times, reception, menu
choices, etc. Work out how many
extra inserts you will need for all
the details. As standard, my
designs include an invitation,
RSVP and a details card.

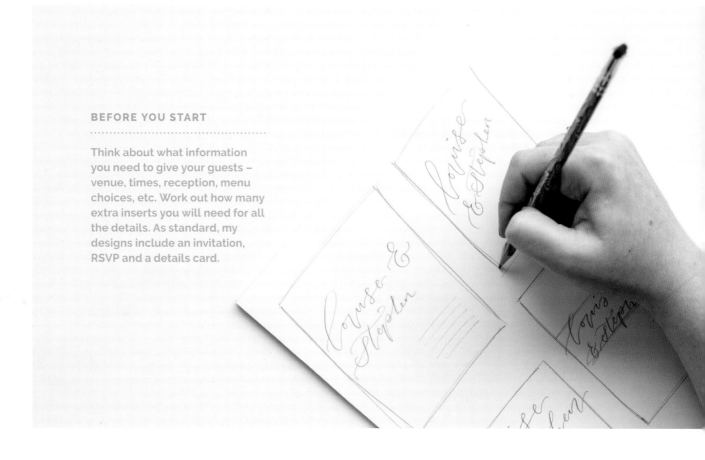

PROCESS

1. Make a mood board. Before starting any design,
I always make a mood board of my ideas and grab
some inspiring images. You can do this online using
Pinterest, or make a physical mood board using
printed-off photos and physical items. Consider all
aspects of the wedding, such as the colour palette,
decor and any fabrics. (My work is largely inspired
by nature, so I use real flowers as a starting point for
illustrations and colour palettes.) A mood board will
give your planning some direction so you're not sitting
with a blank page and no idea of where to begin.

2. Grab a pencil and some paper and get sketching.
This is where I try out all the design ideas that are
buzzing around my head. Scribbles and faux
calligraphy in pencil mean you will be a lot less
precious about something you don't love.

*3. Once you have chosen a design from your sketches,
take the elements that will be done by hand, the
calligraphy and any illustrations, and create them
in ink.* Sometimes it can take me pages and pages
of writing the same names over and over again before
I settle on my favourite style (usually one of the first
I have done!). It is time-consuming but well worth it,
so don't rush.

4. Scan in your final artwork and digitise it (see page
44). I recommend practising your digitising for a while
before starting on your invitations, and ALWAYS save
an original, just in case it all goes sideways.

5. Add in any design elements, such as fonts and
illustrations, and work out your layout using a design
program on your computer. I usually use InDesign for
layouts, but you can use other programs if you prefer.

6. Well done, you've finished your design! Now you
need to send it off to be printed (see pages 46–7),
then wait in anticipation for your wonderful design
to become a reality.

7. Add the finishing touches. Once your invitations are
back from the printers and you have finished stroking
them in awe, you can add some finishing touches,
such as ribbon or twine, a vellum wrap, wax seal
and a fancy envelope.

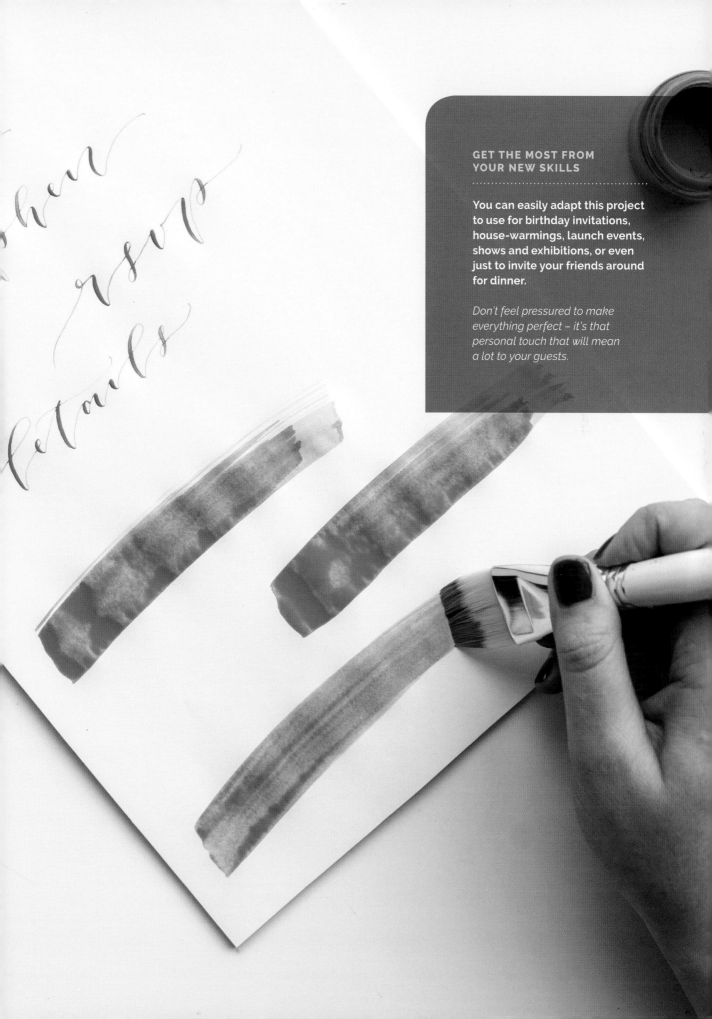

...nd

...omas W...

...u to celebrate their wedding

...ay 26th May 2019 at 4:30pm

Bonj Les Boins

Hvar, Croatia

&

...vens together with Shelley & Mitchell

...a the celebration of the weddi...

...ert *and* Speed

ARE DELIGHTED TO INVITE YOU TO THEIR
WEDDING IN CELEBRATION OF THEIR MARRIAGE

11.08.2018

2PM, THE BARN AT BURY COURT
BENTLEY, FARNHAM, GU10 5LZ
FOLLOWED BY A WEDDING BREAKFAST AND RECEPTION

Save the Date

luxury finishes

MONOGRAM WAX SEALS

A bespoke monogram wax seal adds a timeless, romantic finishing touch to any wedding invitation or envelope that you plan to send out. Now, with your new calligraphy skills, creating a monogram of yours or your loved one's initials should be easy to achieve.

The skill behind bringing two letters together and designing a perfect monogram is all in the sketching. It can take many attempts at writing out the same two letters and fitting them together in different ways before you decide which is best, so make sure you take your time with this step. You will need to find a supplier to create your seal, so it's advisable to do your research before starting in order to find out exactly what companies create and check any guidelines they may have for bespoke designs. Googling 'bespoke wax seals' will bring up plenty of websites, and you can also refer to my recommended suppliers at the back of the book.

YOU WILL NEED

– Sketching paper

– Pencil

– Layout paper

– Circular object (I use rolls of tape)

– Pen holder and nib

– Black ink

– Scanner

– Computer (with design software)

– Melting wax and melting kit

– Hot-glue gun and glue-gun wax

– Scrap paper

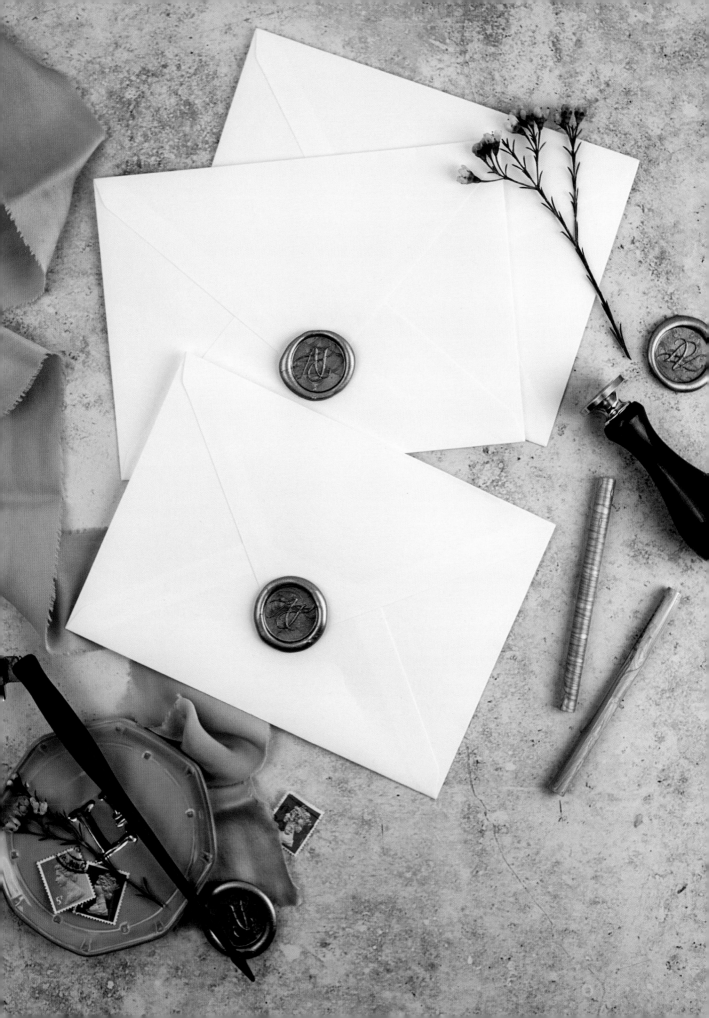

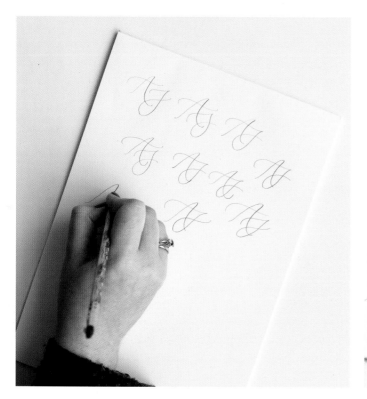

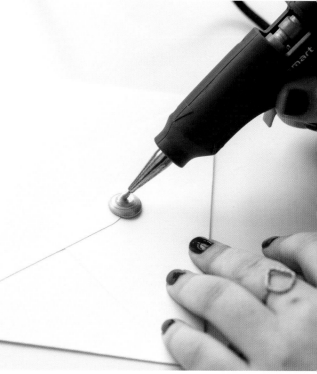

PROCESS

1. Grab some sketching paper and start sketching different ways to bring the two initials together in pencil. Have a look online at different combinations of your letters. Now write them separately, but close together, and see what they have in common. Where one letter ends, can the second begin? Is there a crossover that will work well to have them overlapping? Sometimes, just sitting the letters next to each other is enough and you don't need any overlapping at all. Sketch out all these possibilities, then decide on one or two that work best. If you can't decide, walk away and come back or show someone else. A fresh set of eyes can bring a whole new perspective.

2. When you have chosen your design, ink it up. Again, you may need to do a few versions before you are 100 per cent happy, but keep going and trying it over and over again until you get it right.

3. Now you need to digitise your monogram. If you don't want to do this yourself, you can ask the manufacturers you are using if they offer a digitising service – a lot of them do. Following the steps in the digitising section (see page 44), scan in your chosen design then digitise away. All the companies I have used for customised wax seals check the design first and let me know if anything needs changing before production, so let them know if you have any worries. When ordering your wax seal there are a few size choices. I normally go for 25mm.

4. Once you receive your shiny new monogram seal, it is time to get waxing! It is a good idea to do some test seals first, to get your method right before you begin on your invitations and/or envelopes. You can either use traditional wax and a melting kit or a hot-glue gun and glue-gun wax. The beauty of wax seals is that every one is different, so don't worry if they are a bit wonky – that is part of the charm!

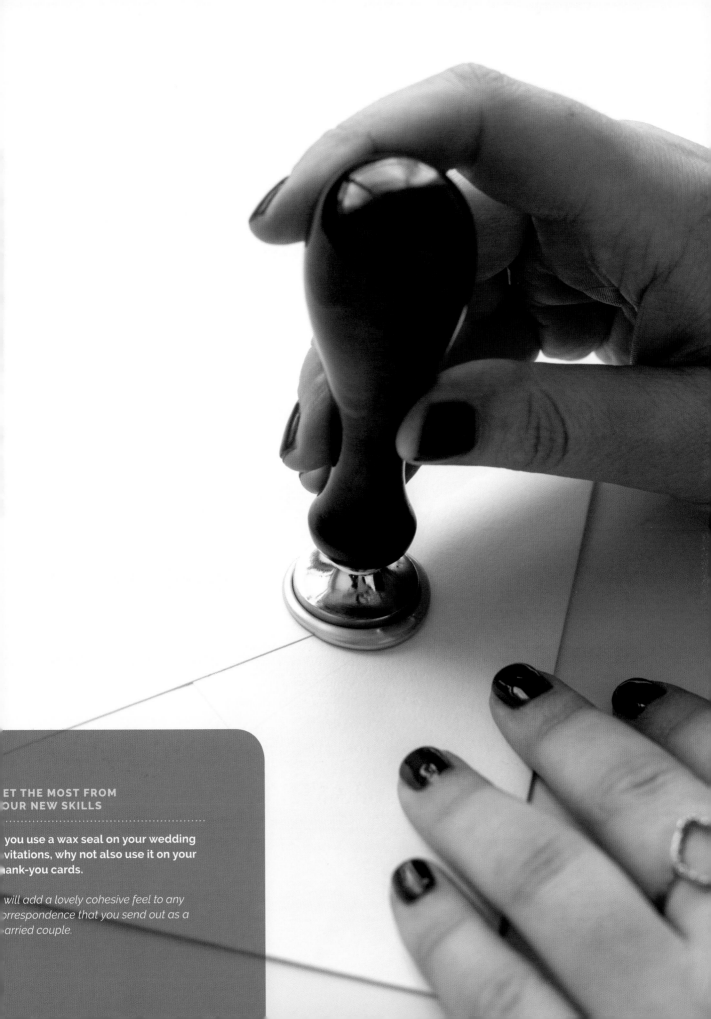

fancy Menus

PERSONALISED MENUS

This personalised menu is a simple and effective way to introduce some calligraphy into your big day. Why not add handwritten details in a sparkly, metallic ink to really make the menu stand out?

For this project, I designed the menus on a computer, printed them out and then added the calligraphy details, but you can design your menus by hand if you don't have a computer.

YOU WILL NEED

– *Computer and printer*

– *Card stock of your choice*

– *Scalpel and metal ruler or guillotine*

– *Pencil and eraser (optional)*

– *Pen holder and nib*

– *Ink*

PROCESS

1. Gather all the information you need for your menus. Make sure that you know all the side dishes and extras that make up each dish. Using a design program (e.g. InDesign) or a word processing program, set up a document. I like menus to be DL size (99 x 210cm), which is long and narrow. Type up your menu, paying attention to spacing between each course.

2. Print out menus – you can use a home printer or a professional printer, depending on your budget. Make sure that the card stock you are printing on is suitable for calligraphy before committing.

3. Take your printed menus and trim them to the size you want (the most accurate way of doing this is with a scalpel and metal ruler or a guillotine). Now add the calligraphy details. If you are worried about getting things straight and central, use a pencil to lightly mark out some guidelines, then erase them once your ink dries. Even if you have printed off your menus in black and white, using sparkly metallic ink that ties in with your tablescape can turn something basic into something beautiful.

GET THE MOST FROM YOUR NEW SKILLS

You can use the steps learned in this project to create a menu for an intimate dinner party for friends or maybe a fancy date night.

Remember, it's good to practise your skills whenever you can!

Courses

Entrée

Fresh Tomato and Mozzarella
Salad with Basil
Or
Smoked Salmon Paté served
with Fresh Sourdough Bread

Main

Fillet of Beef served with Dauphinoise Potatoes
and Seasonal Fresh Vegetables
Or
Grilled Salmon served with Pea and Parsley
Purée and Chorizo Sauce

Fromages

Dessert

Apricot Tartlet with Almond Frangipane
and Vanilla Sorbet

Wines

Côtes du Rhône Villages rouge
Côtes du Rhône Grande Réserve blanc

tag your friends

TAG PLACE SETTINGS

I really like tags as place settings as they are a bit different to the normal folded-card settings. They also fit nicely into the table setting when tied around cutlery with some beautiful silk ribbon. To add a touch of continuity to the setting, you can co-ordinate the ink colour with the colour of ribbon you have chosen to use.

Choose the size of tag that fits with the style of setting you are creating. If it is a modern table design, then a big, bold tag will fit nicely; if more elegant, go for a smaller tag. I like to use a white tag and add colour with the ink, but use a coloured tag if you prefer. I buy all my tags ready-made, but you could use a tag puncher to make your own out of card stock you already have. As always, before committing to any ink, check that it works with your chosen card stock without bleeding.

YOU WILL NEED

– Gift tags (size and colour of your choice; one tag per setting)

– Pencil and ruler (optional)

– Pen holder and nib

– Ink (colour of your choice)

– Soft eraser (optional)

– Silk ribbon (30cm for each setting)

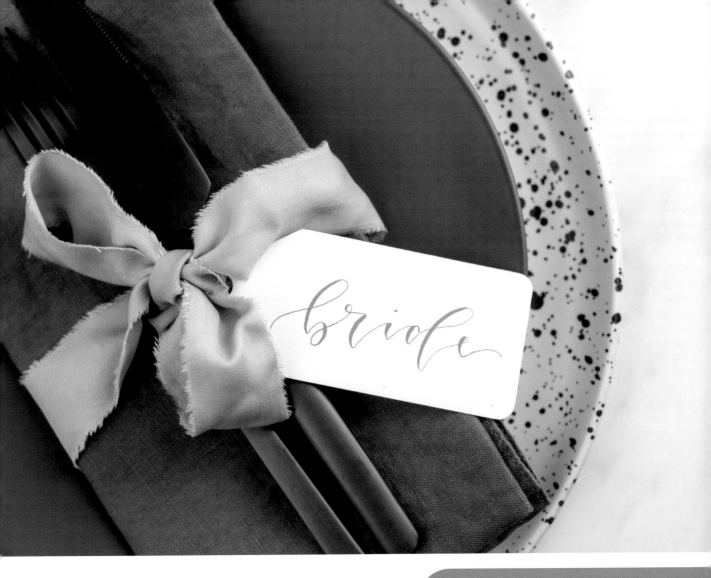

PROCESS

1. *If you feel unsure about your layout and spacing, use a pencil and ruler to draw some guidelines on your tags before writing on them.* If you are really unsure, use a pencil to write out the lettering before applying ink.

2. *Get writing.* Once you are happy with your guidelines, begin to write the names on the tags in ink.

3. *Erase your guidelines.* If you have used pencil on the tag, wait until the ink is fully dried, then use a soft eraser to remove all the pencil marks.

4. *Add the finishing touch.* Thread your silk ribbon on to the tag then wrap it around a set of cutlery, tie a big bow, and place the cutlery in the middle of the plate.

GET THE MOST FROM YOUR NEW SKILLS

Although this project is in the weddings section of this book, you can use the idea for any other type of party or event.

Even if it's just a few people round for dinner, treating your guests to a pretty handmade tag place setting is a lovely touch, and a great way to practise your calligraphy skills.

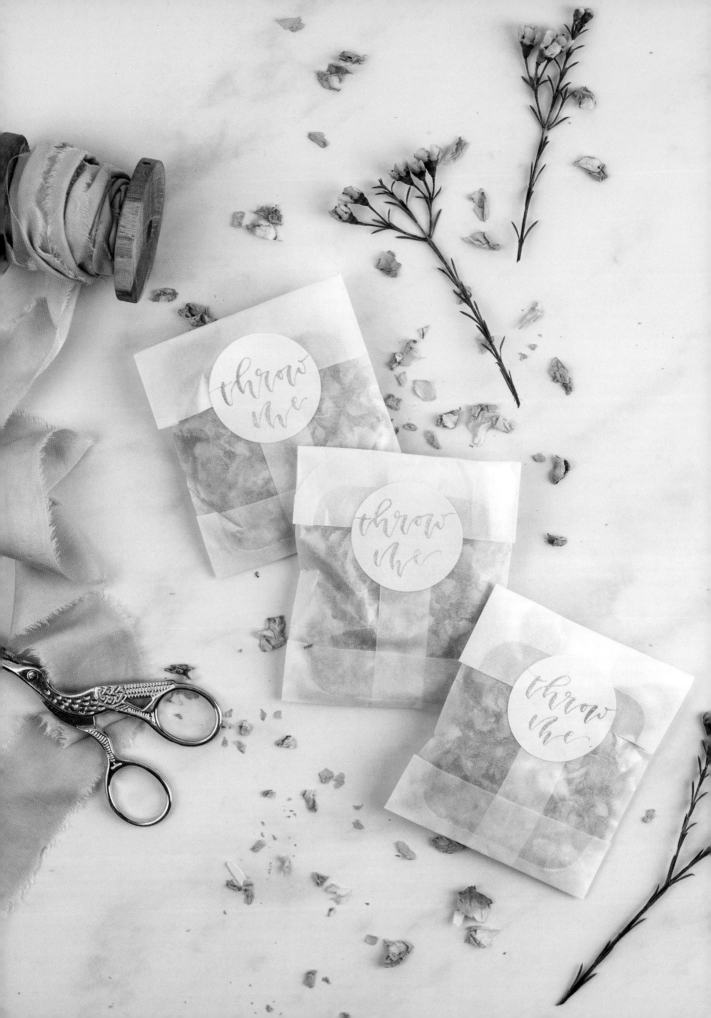

CONFETTI BAG STICKERS

Giving your guests confetti in these cute little glassine bags is a lovely touch. They can be personalised and popped into pockets until the right moment. They also ensure that you have control over what guests are throwing, meaning that any stipulations the venue has (most will only let you throw biodegradable confetti) are taken into consideration. You can also make your confetti all the same colour, which looks great in photos.

When choosing your glassine paper bags, make sure that they are big enough to take a handful of confetti. The stickers need to be a good size to write on so you don't have to cram everything into a tiny space (I use stickers with a 37mm diameter). Before you begin to write lots, test run a sticker to check that it takes the ink and doesn't bleed. You may need to thicken your ink slightly with some Gum Arabic.

YOU WILL NEED

- *Circular uncoated paper stickers (ones designed for laser printers are good)*
- *Pen holder and nib*
- *Ink*
- *Glassine paper bags*
- *Dried rose petal confetti*

PROCESS

1. ***Decide on the wording that you want to use*** – I have used the very basic 'throw me', but you could write your names on it, or some other confetti pun if you prefer. Write out your text on however many stickers you want to use and leave to dry.

2. ***While the stickers are drying it is time to get stuffing.*** Stuff each glassine bag with a handful of confetti, making sure that it isn't too full, as you will need to fold over the top of the bag.

3. ***Once your stickers are dry,*** fold over the top of the bag and stick your sticker on to seal it up. Pop the confetti bags in a cute basket or box and they are ready to be handed out after your ceremony!

GET THE MOST FROM YOUR NEW SKILLS

You can use this project to make goody bags for children's parties.

Just change the wording to 'eat me' or 'help yourselves'...

make every table special

GLASS FRAME TABLE NUMBERS

These photo frame table numbers are a great thing to DIY for a wedding or event. You can choose whatever frames and decorative leaves go with your decor and they will add a lovely green flare to your table settings.

I chose fern leaves and a glass frame with gold edges to place in the middle of the table, but you can choose whatever suits your event. Think about your table size when choosing a frame. Standard frame sizes are 10 x 15cm or 13 x 18cm. Depending on how soon in advance you are making your frame, you might want to dry the leaves or flowers first so that they don't start to go brown before the event.

YOU WILL NEED

- *Double-sided glass photo frames of your choice*
- *Polish and cloth*
- *Decorative leaves and/or flowers*
- *White Uni POSCA Markers*

PROCESS

1. *Clean and polish the glass of the frame* to remove marks and dust.

2. *Place the leaves and/or flowers inside the frame and tweak the position until you are happy.* Once in the correct place, you can decide where to do your lettering so they sit well together and don't clash.

3. *Put your frame back together and, using a white Uni POSCA Marker, write your table number or name on the front.* If you make a mistake, you can wipe it off while it is still wet. Once the pen has dried, you can remove it by scratching it gently, but be careful not to damage the glass.

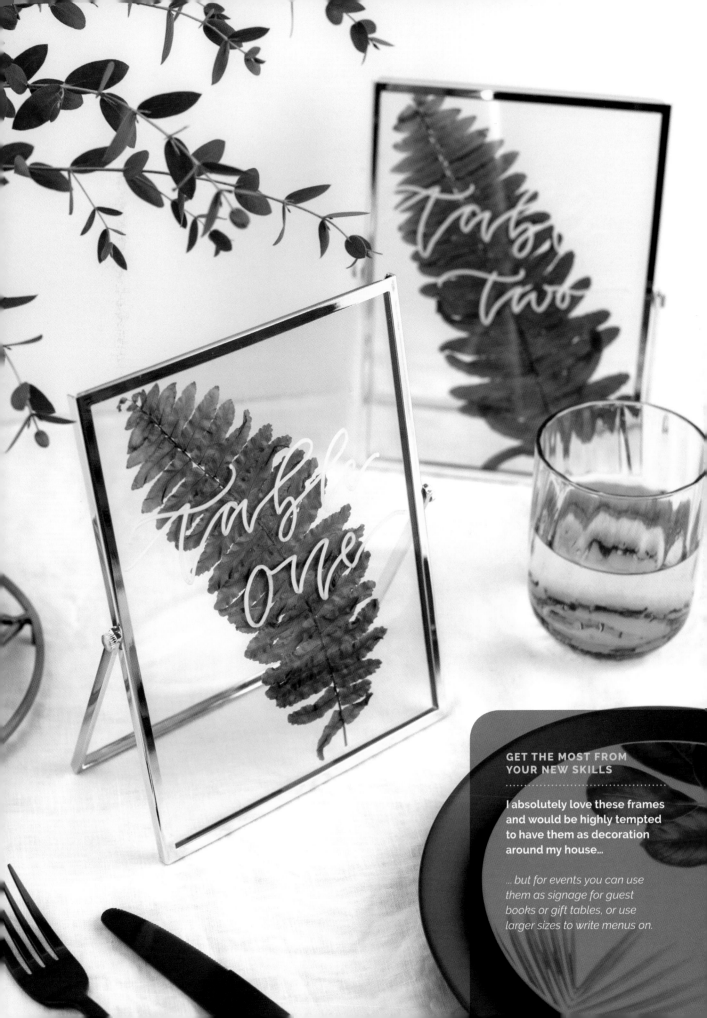

find your seat

STRING TABLE PLAN

The beauty of this project is it can lend itself to so many different forms of decor. You can string these up on a blackboard, an empty vintage frame, reclaimed shutters or a sanded-down door. If your venue has a plain brick wall, you can even hang them up on that.

I buy pre-cut card for all projects, but if you only have sheets of A4 then cut them to size. If you want thin pieces, 4 x 10cm is a good size, or if you want larger then 8 x 10cm is also a good size, especially if you want more space to add first names and surnames. Pick the colour of card and ink that you want to go with your decor and then match this to the string. The length of your string will depend on two things: how many cards you have to hang up and how much space you have to hang up your table plan. Before cutting your string, lay out a few cut-to-size plain cards and leave enough breathing space between each. This will give you a good indication of how much string to allow. Remember to always cut an extra 30cm so that you don't run short when you hang up your plan. You can always trim it once everything is in place.

YOU WILL NEED

– White card

– Pencil and ruler or laser level (optional)

– Pen holder and nib

– Coloured ink

– Drying rack

– String

– Mini wooden pegs

– Herbs or greenery

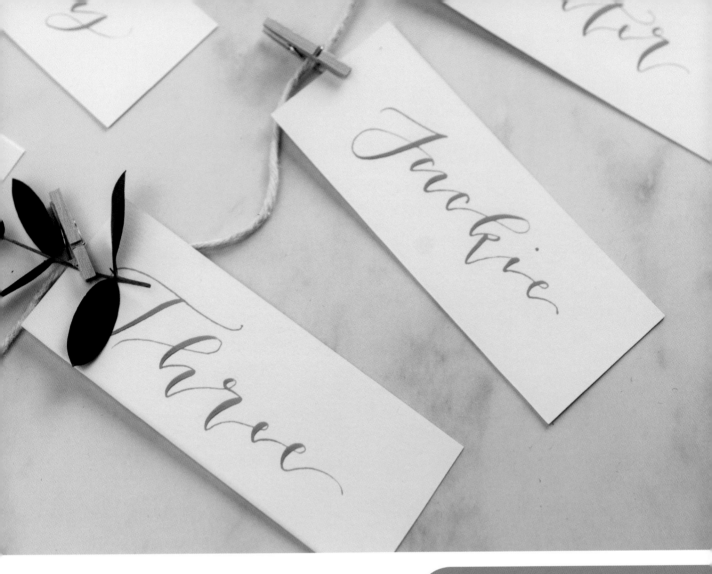

PROCESS

1. Cut your card down to size. If you need to, draw guidelines on them or use a laser level to keep your writing straight.

2. Write all the names on the cards and then pop them on a drying rack to dry. Don't forget to write the table name or number on the cards as well, so you can add them to the beginning of the rows.

3. Once the cards are dry, cut your string to length. Using mini pegs, clip the cards and a decorative sprig of herbs or greenery for each one to the string.

4. You're done. Hang up your table plan wherever you wish.

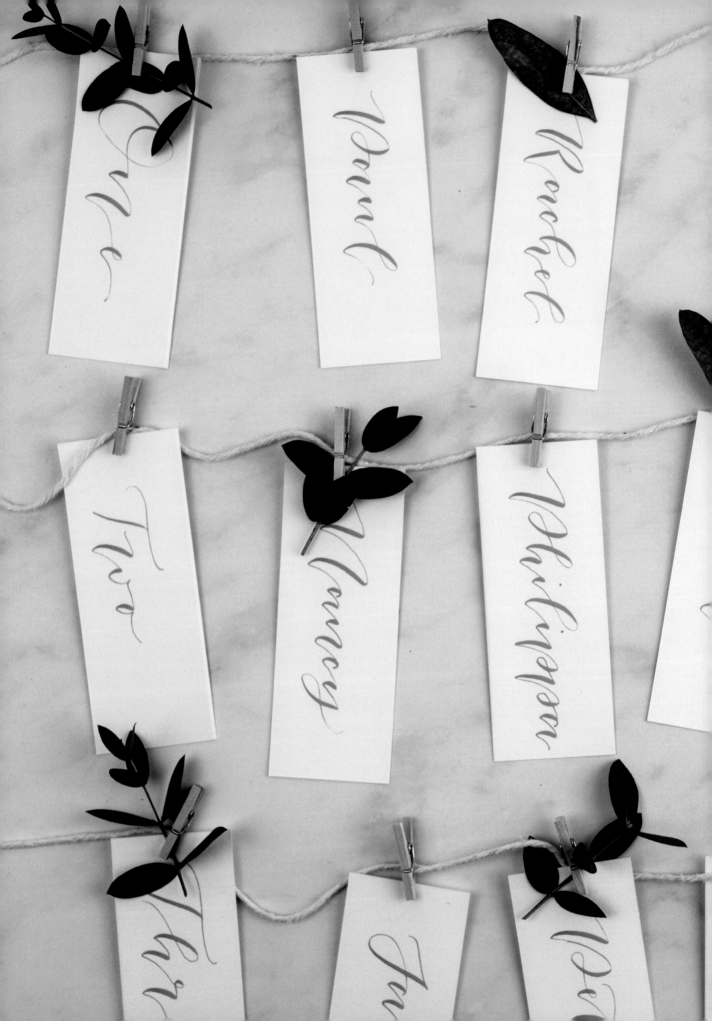

thank you

BESPOKE STAMP
THANK-YOU CARDS

Post wedding, when you are feeling a little short of cash but want to send a big thank you to all your friends and family for their love and support, this little DIY project is perfect. Making the most of your calligraphy skills to create personal thank-you cards for everyone is the ultimate way to show how grateful you are.

I use The English Stamp Company to make up my stamps. I scan my design into the computer, clean it up in Photoshop and send them a high-resolution jpeg. You should check with your supplier what format they need, and work to that. Make sure the size of your stamp lines up with the size of card that you are using. I decided to go for A7 cards (A6 folded), so I made my stamp to that size, with a little breathing space around the edges. You can use a normal stamp pad and just stamp your cards or, for a little more sparkle, follow the last steps to heat emboss your lettering!

YOU WILL NEED

– *Layout paper*

– *Pencil*

– *Pen holder and nib*

– *Black ink*

– *Computer and scanner*

– *A7 cards and envelopes*

– *Embossing ink pad*

– *Embossing powder*

– *Soft brush*

– *Embossing heat tool*

friendly plants

PLANT POT FAVOURS

This is one of my favourite projects. It's so simple yet the effect is amazing, and it also provides something special that your guests can take home to remember your big day by.

The pots that I use are plain terracotta 7cm pots and the succulents are mini 6cm pot plants. You can buy different sizes if you like. The best pens to use are Uni POSCA Markers. I used the medium-nib PC-3M, which is the perfect size for my style but, in general, it is a good idea to have a few sizes on hand to test out. I used white on the terracotta, but feel free to change the colours as you wish.

YOU WILL NEED

– *Plain terracotta plant pots (7cm)*

– *Kitchen paper*

– *White Uni POSCA Marker*

– *Mini succulents*

PROCESS

1. Give your pots a wipe over with a piece of dry kitchen paper to get rid of any dirt or dust that might be clinging to them.

2. Rest a pot in the palm of your hand and use your little finger as a balance for the pen when writing. Go slowly, and don't feel like you need to do the whole word or name in one go. It's fine to break and pick it up again.

3. If you want the faux calligraphy look, then, once dry, go back and thicken up your downstrokes.

4. Pop a tiny plant into your pot, and your favour is ready to go!

GET THE MOST FROM YOUR NEW SKILLS

These are the cutest of gifts. They don't only have to be made for a wedding or event.

You could make them for your best friend's birthday or write words of encouragement on them for someone who is having a tough time. If you want to go crazy, then use some acrylic paint to add patterns around your calligraphy. You and your friends will soon have houses full of these cute plant pots.

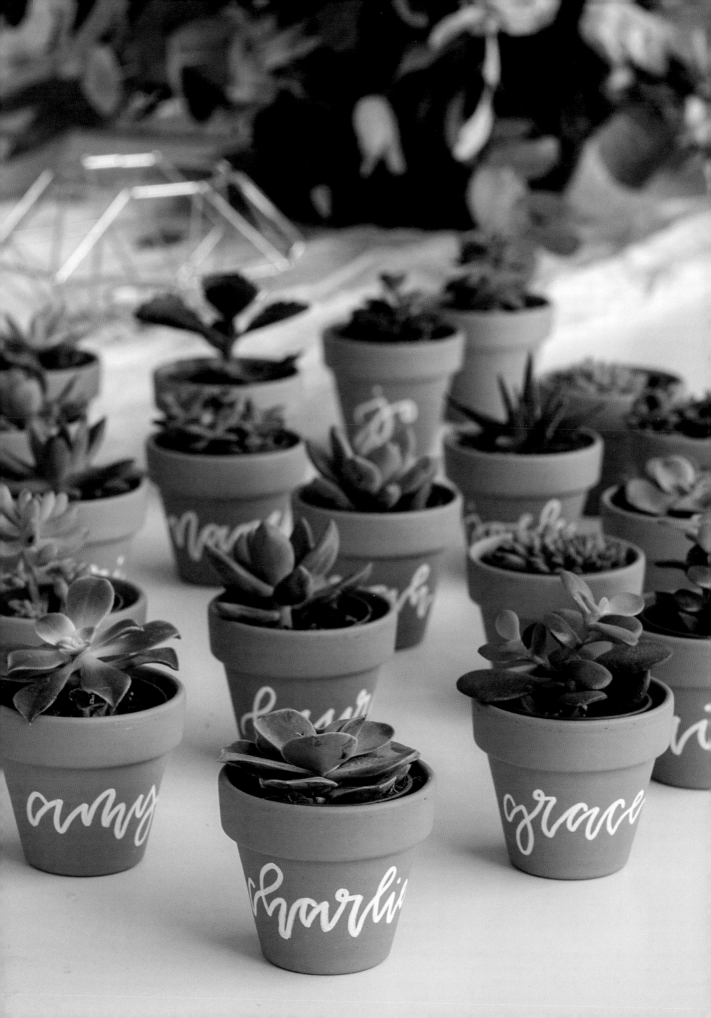

PROCESS

*1. Decided on the size and wording you want for
your cards.* Plan it out on some layout paper and
start sketching ideas for your lettering, utilising the
space that you have.

*2. When you have chosen the lettering you want to
use, it is time do it in black ink.* You can either trace
over your pencil sketches or write it freehand.

*3. Scan it in (see page 44) and send it to the stamp
makers.* If you are going to heat emboss, then make
sure you buy the correct ink pad for this.

*4. Take out your blank cards and stamp the design
on to the card*, using the embossing ink pad.

*5. Next, take the embossing powder and sprinkle
it all over the design.* Shake off the excess powder,
brushing any extra bits off with a soft brush if need
be. Gently run the heat tool over the powder. This
will warm up the powder and cause it to melt, leaving
you with a gorgeous foil effect on your lettering.

6. Pop your embossed card in a matching envelope,
and add some calligraphy as a finishing touch.

celebrations

---— **CHAPTER FOUR** —---

Be prepared for all occasions!

From Mother's Day to birthday bashes, this chapter provides plenty
of thoughtful gift ideas, and lots of opportunities to show off
your new calligraphy skills.

Send some love

VALENTINE CONFETTI ENVELOPES

Is there anything more romantic than a handwritten love note? I think not. This project is a great excuse to practise and show off your calligraphy skills. And it doesn't have to just be for Valentine's Day. Why not send one to your mum or your best friend – I guarantee it will make them smile.

I made my note in traditional colours of love – red and pink, with a little bit of gold sparkle thrown in – but of course you can use any colours you choose. You want the card you're cutting out to be 160gsm (check your punch for specific weights) or less, otherwise the heart punch will not go through it.

YOU WILL NEED

– Heart-shape craft punch

– Pink and red card stock (160gsm)

– Gold non-shedding card stock

– A6 notecards and envelopes

– Pen holder and nib

– Ink

– Pencil and eraser (optional)

PROCESS

1. **Using your heart punch,** cut out lots of little hearts in an assortment of colours of card stock, and place to one side.

2. **Write your loving message on to the notecard.** Use pencil guidelines if you need to, you can always erase them after.

3. **Address the envelope,** either with just a name or a full address, and pop everything into the envelope – the notecard and the heart cut-outs – and you're ready to surprise your Valentine.

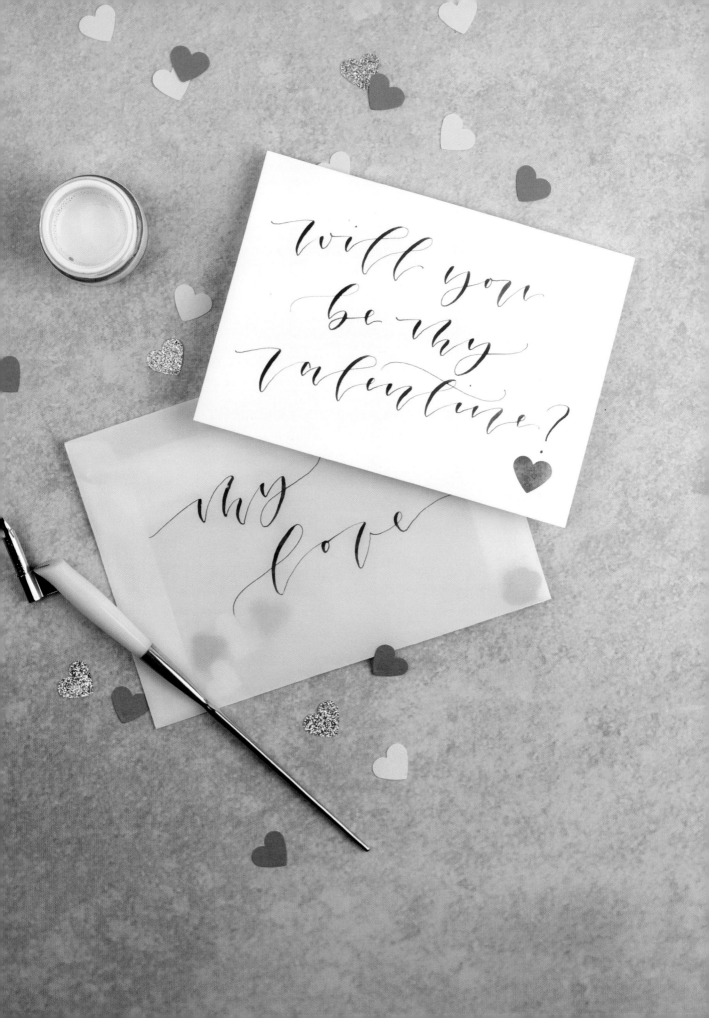

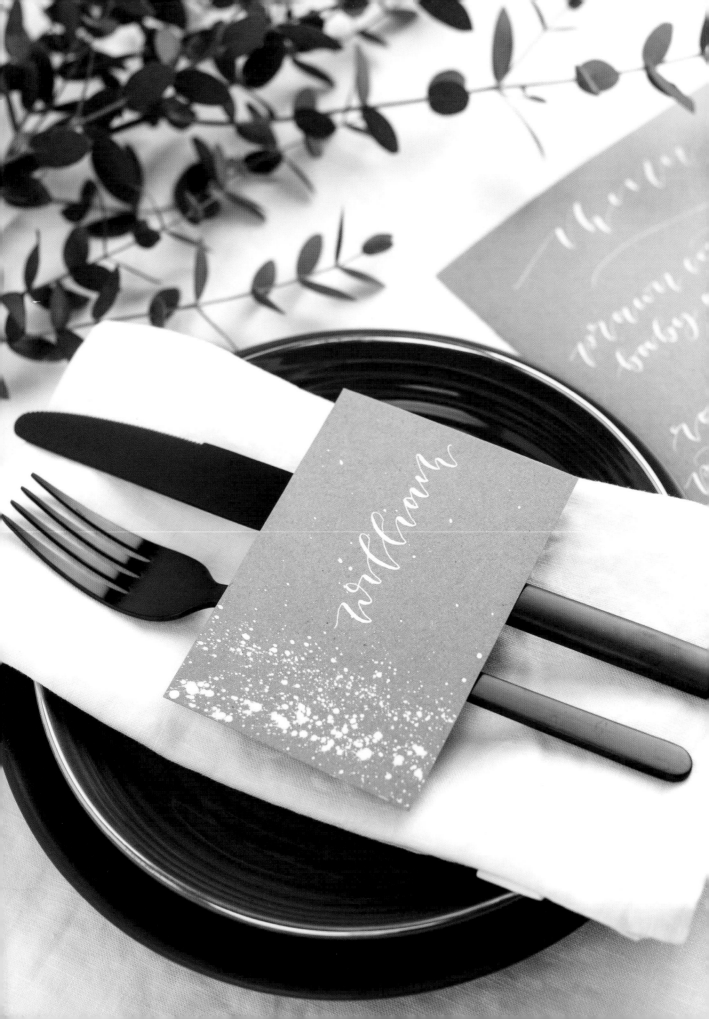

SNOWY MENU AND PLACE CARDS

These Kraft-and-white menus and place settings make for a simple and effective setting for the holiday season when you invite your family and friends over for dinner.

I love the look of Kraft-coloured card with white ink. Some of it can be a bit rough though, which means you need to make sure you test the card first with your nib and opt for the smoothest possible card.

PROCESS

1. Cut your card to size. I used A5 for the menus and A7 for the place settings. The most accurate way to cut down your card is either with a scalpel and metal ruler or a guillotine.

2. Place the smaller pieces of card (place settings) on to a piece of scrap paper. Get your paintbrush, dip it in the ink and then flick it all over the card to create a splatter effect. I like to just splatter the side to leave a clean space in which the lettering can go without fighting for attention against the splatters, but it is up to you. Have a play around and see what you prefer. Leave to dry completely on a drying rack. Depending on the thickness of your ink, I would wait at least an hour.

3. Take your pen holder and nib and, using the same white ink, write the names on to your place settings and the courses on to your menu. Remember, feel free to draw in pencil guidelines if you are a bit unsure of your straight-line capabilities, then simply erase them when you have finished.

YOU WILL NEED

– *Kraft card (A5 and A7)*

– *Scalpel and metal ruler or guillotine*

– *Scrap paper*

– *Paintbrush*

– *White ink*

– *Drying rack*

– *Pen holder and nib*

– *Pencil and eraser (optional)*

GET THE MOST FROM YOUR NEW SKILLS

These don't have to be just for the snowy holiday season.

You could swap the Kraft for white card and the white ink for fluorescent ink to jazz up a party menu and place settings.

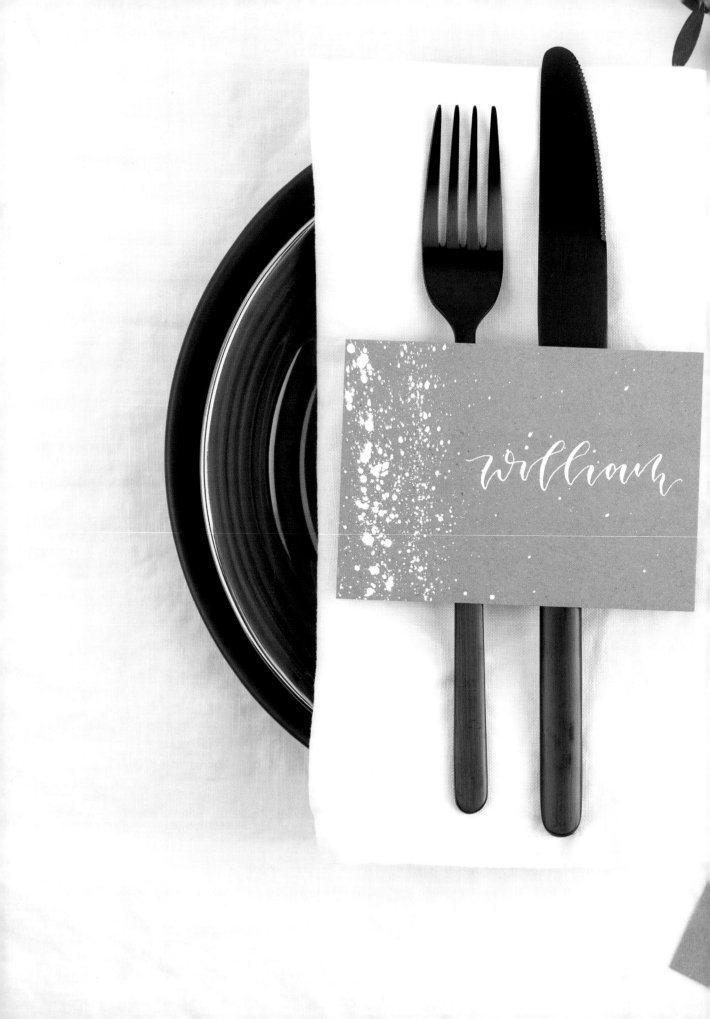

Menu

prawn cocktail with
baby gem lettuce

roast turkey with
potatoes, seasonal veg
& homemade gravy

sticky toffee pudding
with vanilla
ice-cream

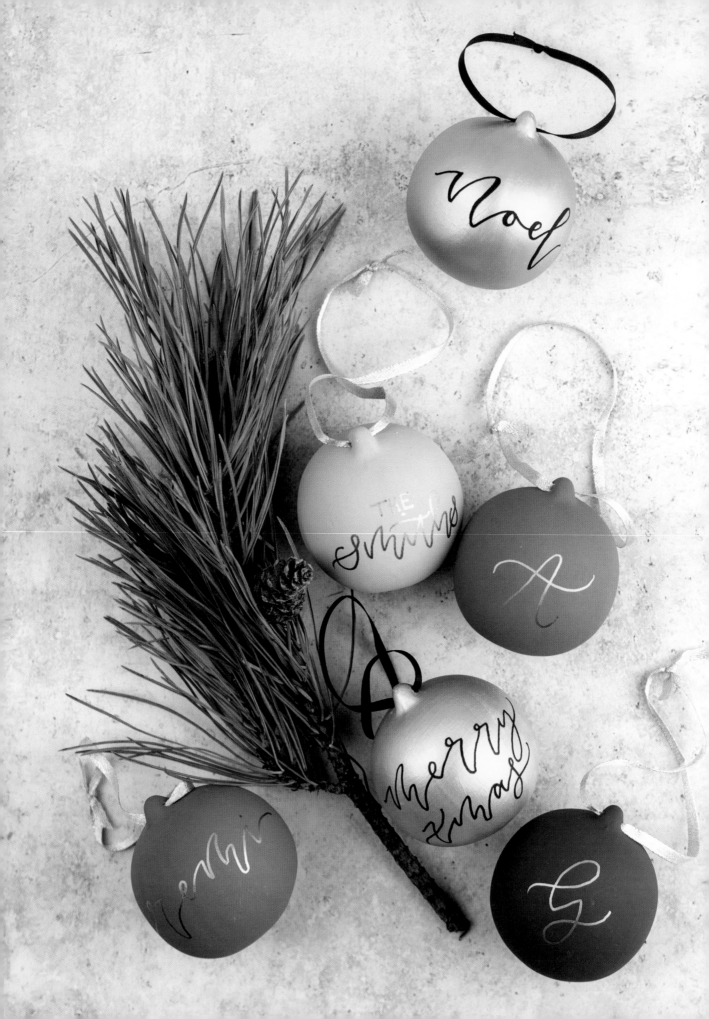

happy holidays

FESTIVE BAUBLES

These festive baubles make gorgeous decorations or personalised gifts for friends and family. They are pretty easy to make and, while you might need some practice writing on a curved surface, you will quickly get used to it. The faux calligraphy with paint pens creates a lovely thick effect that really stands out when the baubles are hung up.

I use white ceramic baubles when making these personalised decorations because the ceramic is smooth and easy to paint on, and they are also well weighted. You can buy baubles online or from hobby stores. I like to pick contrasting colours that look good together. If you are making these for a friend, take into account their decor tastes. My favourite paint pens are Uni POSCA Markers and Sakura Pen-touch. For metallic, I would go for Sakuras; for white and black, Uni POSCA Markers are better. Extra-fine nibs are best for this size of work, but you could use fine if you want a thicker line. It is best to try both and see which you prefer.

YOU WILL NEED

– *White ceramic baubles*

– *Damp cloth*

– *Matte acrylic paint*

– *Flat paintbrush*

– *Empty jar*

– *Scrap paper and pencil (optional)*

– *Paint pens (Sakura Pen-touch or Uni POSCA Marker)*

– *5mm satin ribbon (20–30cm lengths)*

– *Toothpick (optional)*

PROCESS

*1. **Give your baubles a good dusting** to make sure that they are thoroughly clean.* You don't want any particles getting in the way when you paint as you need a perfectly smooth surface to write on.

*2. **Using an acrylic paint and a flat paintbrush, start painting your bauble.*** I find that it is easiest to do it in halves. Hold it by the ribbon and do the top half first then leave it for a couple of minutes to dry to the touch. Next, place it upside down in a jar and paint the bottom half. Again, leave it to dry for a few minutes, then repeat the process to apply a second coat. Once your second coat is finished, hang up your bauble and leave it to dry. I use matte acrylic paint and find that 5 minutes between coats is enough for it to be dry to the touch. However, before writing on it you want your bauble to be completely dry so as not to bung up your pen. Leave overnight if possible.

*3. **Once your baubles are totally dry you can start writing your messages.*** If you are nervous about the lettering then practise on some paper first. Choose a pen that complements the bauble colour, then slowly and carefully begin to write your lettering. I hold the bauble in my left hand and use my little finger on my right hand to steady myself as I do the lettering. It may take a couple of tries to get the lettering perfect to start with, so have a few extra baubles on hand in case you mess up. However, take heart since once you have figured out the best position for you it will become much easier.

*4. **Take a complementary-coloured ribbon (I like to match it to the lettering) and string it through the bauble.*** Using a toothpick can make this easier if it's a small hole. You now have a fancy festive bauble, ready to adorn your tree or to give to a loved one.

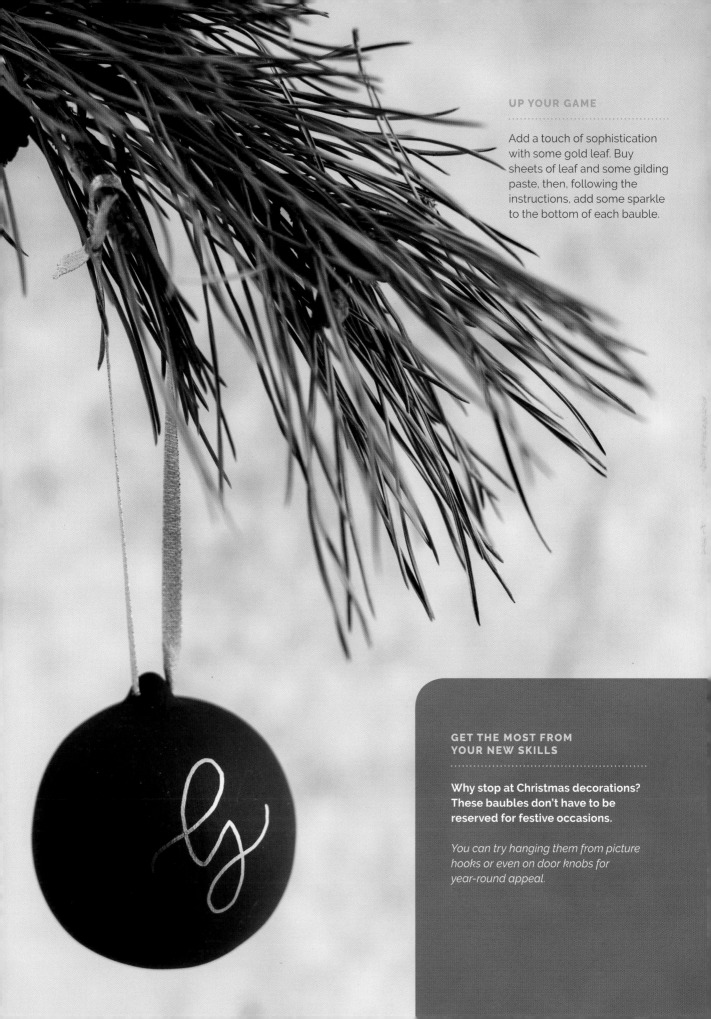

UP YOUR GAME
..

Add a touch of sophistication with some gold leaf. Buy sheets of leaf and some gilding paste, then, following the instructions, add some sparkle to the bottom of each bauble.

GET THE MOST FROM YOUR NEW SKILLS
..

Why stop at Christmas decorations? These baubles don't have to be reserved for festive occasions.

You can try hanging them from picture hooks or even on door knobs for year-round appeal.

wrap it up

WRAPPING PAPER

As I started this project, I wondered why I had never used something like this to wrap presents in before. Needless to say, everyone I know will now be receiving gifts wrapped in handwritten paper. It's slightly time-consuming, but well worth it, and adds the perfect personal touch, especially when coupled with a handwritten gift tag and card.

I used brown Kraft paper for this project, but you can experiment with different types of paper in any colour. You want something plain that your calligraphy stands out against and something uncoated, otherwise your ink will bead on the surface. The paper should also be good quality to prevent the ink from bleeding. I chose flat sheets so they didn't curl up as I wrote; you could cut some off a roll but you will have to weight down the sides.

YOU WILL NEED

– Flat sheets of plain, coloured wrapping paper

– Scalpel and metal ruler or guillotine

– Pencil, ruler and eraser or laser level (optional)

– Pen holder and nib

– Ink

– Ribbon and handwritten tag

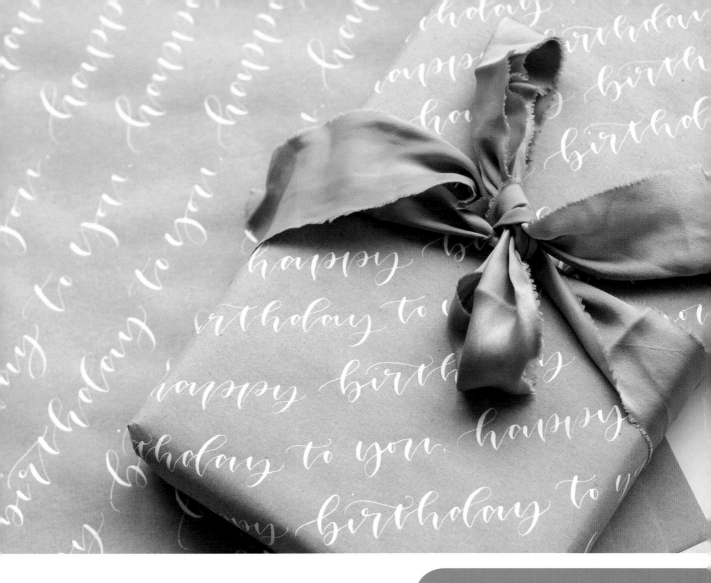

PROCESS

1. Cut your paper to size, leaving a bit extra on the sides.
You don't really want to write more than you need to unless
you want to keep some in stock for upcoming birthdays.

2. Decide at what angle you want to write. I like diagonal, but
straight can work too. Because I went diagonal I did it by eye.
It did start to curve a little, but I liked it so I wasn't worried about
guidelines. If you're worried, use a pencil and ruler to mark out
lines you can erase later, or use a laser level.

3. Get writing. Decide what you want to write and whether you
want to repeat it or not. I kept it simple with 'happy birthday to
you' repeated, but you could use a poem or the recipient's
favourite quote if you wanted.

4. Let it dry properly before attempting to wrap anything in it.
Once it is dry, wrap the present up, add an elaborate bow and
handwritten tag, and there you go. Perfect thoughtful gift… done!

GET THE MOST FROM YOUR NEW SKILLS

**By changing the words you are
lettering on the paper, you can
use this project for any kind of
celebration or event.**

*It is a great and unusual way of
personalising a present – who wouldn't
want a gift wrapped in paper with their
name written in beautiful calligraphy
all over it?*

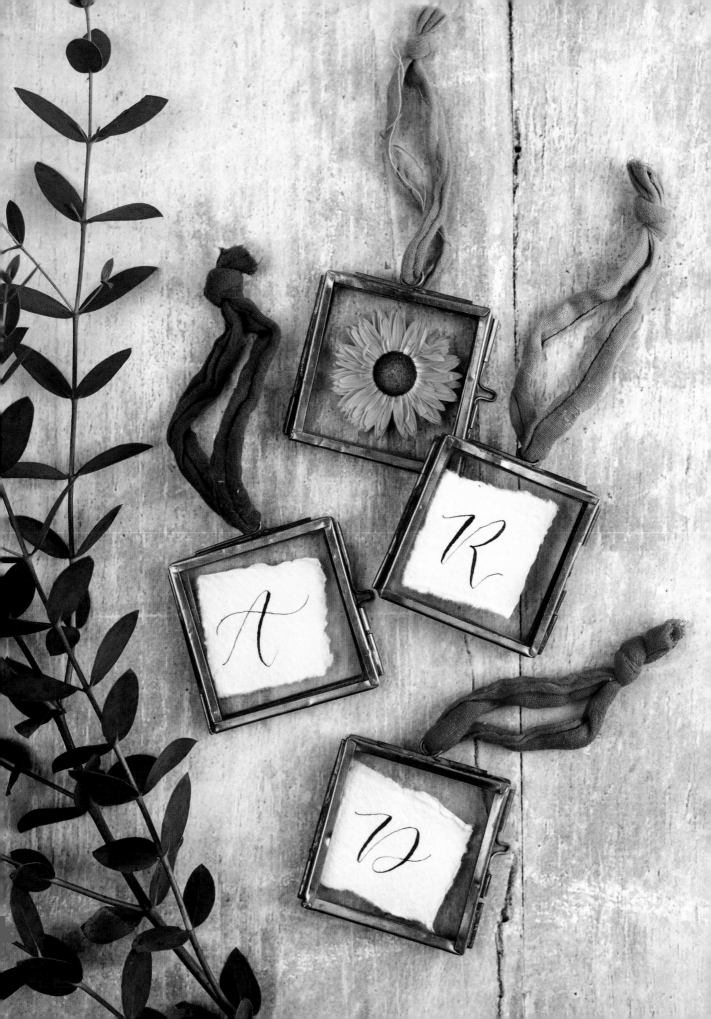

dear Mum

MOTHER'S DAY
FRAME DECORATIONS

This delicate Mother's Day present is simple yet effective, and full of love and thoughtfulness. I chose to put initials of children in the frames, but you can put birthdays or even, if it's for a new mother, her newborn's birth measurements.

I used handmade cotton paper by Khadi in my frames because I liked the rustic torn-edge look inside the dinky little frames. However, it is slightly tricky to write on due to the fibres and textures, so if you're new to calligraphy you might be better off using a card stock that is smooth and that you're used to writing on.

YOU WILL NEED

– *Handmade cotton paper*

– *Miniature hanging frames (I used Nkuku, which are 5 x 5cm)*

– *Pen holder and nib*

– *Ink*

– *Pressed flowers (optional)*

– *Tissue and gift box*

PROCESS

1. *Cut or tear your paper to size to fit in the frames.* I like the paper to be slightly smaller than the frame so there is a gap, but you can make them the exact same size if you prefer.

2. *Write your chosen messages* on the pieces of paper and place them in the frames.

3. *Spare frames?* If you have any frames left over then get some dried or pressed flowers and place them in the empty frame.

4. *Wrap them gently in tissue and place in a gift box,* ready to give to your mum or loved one as the perfect thoughtful Mother's Day gift.

GET THE MOST FROM YOUR NEW SKILLS

These little frames also look very cute hanging from a tree, so why not turn them into a holiday project and adorn your Christmas tree with loving memories.

dear dad

FATHER'S DAY
LEATHER KEYRING

Leather is a fun surface to write on, and the perfect material with which to make presents for the men in your life. Using an eyelet setter and split rings, it's simple to make a lovely little key ring, which you can personalise with a name or favourite place such as 'Dad's Shed'.

You can buy leather squares from online leather retailers relatively cheaply and in a variety of colours. I chose dark brown and accessorised with brass eyelets and key rings. Acrylic leather paint also comes in a variety of colours. I thought white went best with my project.

PROCESS

1. Cut your leather to size using a scalpel, metal ruler and cutting mat, I suggest testing out your message on a piece of spare leather to see what size will fit the wording you want to use. I made mine 2.5cm x 5cm for the shorter ones and 2.5 x 7.5cm for the longer ones, leaving space for the eyelet.

2. Using your hole punch, punch a 5mm hole in the leather for the eyelet.

3. Now, using the eyelet setter, pop in an eyelet and fix it.

4. Create your lettering using the leather paint and a small paintbrush. Don't use too much paint in one go. Build it up slowly in thin layers. Keep going back over it until you are happy with the opacity.

5. Leave to dry completely before attaching a split ring for a perfectly hand-crafted leather key ring.

YOU WILL NEED

- *Squares of leather*
- *Scalpel*
- *Metal ruler*
- *Cutting mat*
- *Hole punch*
- *Eyelet setter (I use a Crop-A-Dile)*
- *5mm eyelets*
- *Angelus white leather paint*
- *Paintbrush, size 2/0*
- *25mm split rings*

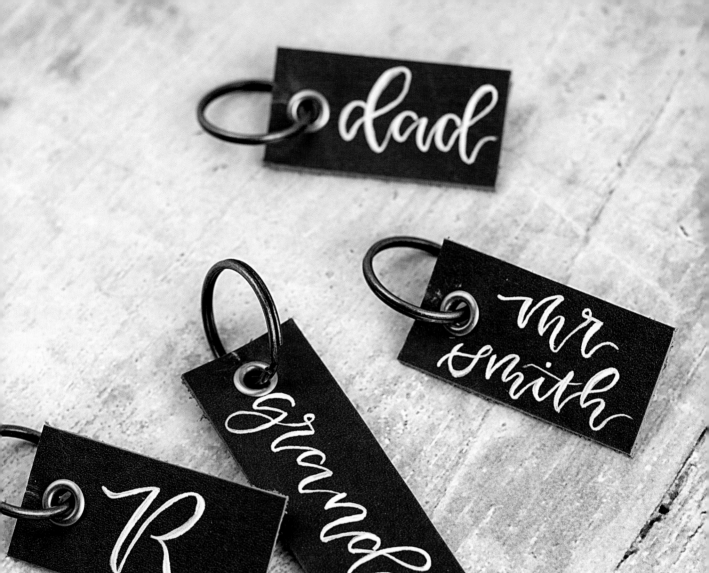

GET THE MOST FROM
YOUR NEW SKILLS

If you are getting married or have an
event coming up, these little squares
of leather could make an unusual
place setting.

*Or, just use these skills to make key
rings for everyone you know – we all
have keys, after all!*

STOCKISTS & SUPPLIERS

CALLIGRAPHY TOOLS
Blots pens
www.blotspens.co.uk

Scribblers
www.scribblers.co.uk

Rainbow Silks
(Pearl Ex in the UK)
www.rainbowsilks.co.uk

Cult Pens
(Paint pens and fineliners)
www.cultpens.com

FANCY PEN HOLDERS
Tom's Studio
www.tomsstudio.co.uk

Ash Bush
www.ashbush.com

PAPER STOCKS
GF Smith
www.gfsmith.com

PDA Card & Craft
www.pdacardandcraft.co.uk

PHOTOGRAPHY BACKDROPS
Capture by Lucy
www.capturebylucy.com

RIBBONS
Kate Cullen
www.katecullen.co.uk

WAX SEALS
Custom Wax N' Seals
www.customwaxnseals.net

Stamptitude
www.stamptitude.com

Artisaire
www.artisaire.com

STAMPS
The English Stamp Company
www.englishstamp.com

PHOTO FRAMES
Paperchase
www.paperchase.co.uk

Nkuku
www.nkuku.com

CERAMIC BAUBLES
Baker Ross
www.bakerross.co.uk

Hobbycraft
www.hobbycraft.co.uk

ART SUPPLIES
Cowling & Wilcox
www.cowlingandwilcox.com

Hobbycraft
www.hobbycraft.co.uk

Cass Art
www.cassart.co.uk

ACKNOWLEDGEMENTS

To Joanne at Haynes for seeing the potential in me and believing I could make this book a reality.

To my mum and dad for your never ending support and encouragement.

To my grandparents for always being proud of me and for giving me my first book about calligraphy.

To my sister for being my loudest cheerleader and biggest inspiration. You are a wonder woman, and always know exactly the right thing to say to me.

To the wonderful Holly Booth for somehow deciphering all my random notes and explanations to bring together the best photos I could ever ask for.

To Steve for being the best boyfriend and dad through all of this and 'most' days. I love doing life with you. Thank you for designing this book, with me peering over your shoulder making wild demands, so perfectly.

To my stationery buddies for celebrating my wins with me, and picking me up after my losses. You guys are the definition of community over competition and I would be absolutely lost without you.

To my best friends for surrounding me with positive vibes and support, from near and far.

To my in-laws for being emergency babysitters whenever my 'schedule' fell apart.

To Tom, Lucy and Kate for lending me the most stunning of props – you guys are so talented and it has been an honour to work with you.

And lastly, to the gorgeous little human I grew – just for being here. I love you more than words can ever explain.

ABOUT THE AUTHOR

Lauren Cooper began her journey into the world of calligraphy in 2012, and launched Oh Wonder Calligraphy in January 2016, offering a range of bespoke services to the wedding and events industries. Lauren also runs calligraphy workshops in London and the South East.

Based in South East London, Lauren works out of her garden studio; attached to the home she shares with her partner and their son, and not forgetting their sausage dog, Lincoln.

Featured in a number of high profile publications such as *Mollie Makes*, *Red* magazine and *Wedding Ideas*, she has also worked with brands such as The White Company, ZSL, Ferrero Rocher, Tata Harper and Laura Mercier.

www.ohwondercalligraphy.com
@ohwondercalligraphy